SYDENHAM
& FOREST HILL

THROUGH TIME

Steve Grindlay

AMBERLEY

Acknowledgements

Over the years, the staff and resources at the Lewisham Local History & Archives Centre have proved invaluable when researching the history of this area. I am also grateful to them for permission to publish several images from their collection.

I am also grateful to the Croydon Museum for permission to use the view of Sydenham Common on page 5.

First published 2014

Amberley Publishing
The Hill, Stroud, Gloucestershire, GL5 4EP
www.amberley-books.com

Copyright © Steve Grindlay, 2014

The right of Steve Grindlay to be identified as the Author of this work has been asserted in accordance with the Copyrights, Designs and Patents Act 1988.

ISBN 978 1 4456 3492 0 (print)
ISBN 978 1 4456 3513 2 (ebook)

British Library Cataloguing in Publication Data.
A catalogue record for this book is available from the British Library.

Typesetting by Amberley Publishing.
Printed in Great Britain.

Introduction

For centuries, Sydenham was a small hamlet on the edge of a large tract of common land, known as Sydenham Common, in the parish of St Mary's, Lewisham. There were several wealthy landowners and farmers, but for the most part the residents were agricultural labourers with a few shopkeepers and tradesmen. London was more than an hour's travel away.

In the 1640s, mineral springs on Sydenham Common were discovered to have medicinal qualities. Daniel Defoe, who visited Sydenham Wells in the 1720s, wrote that those who came to take the waters were 'unruly and unmannerly' and 'the better sort declined the place'. Several of Sydenham's earliest pubs were built to provide accommodation, and something stronger than spring water, for the visitors.

Forest Hill is more recent. One of the earliest references was on 8 July 1794 when an advertisement appeared in *The Times* offering 'a valuable freehold estate, in a singularly beautiful situation, upon Forest Hill, near Sydenham Common'. At this time, 'Forest Hill' referred to some eight houses that were being built along the upper part of Honor Oak Road.

Over little more than fifty years, three events radically altered Sydenham and Forest Hill, turning the area from a rural hamlet into a populous, even fashionable, suburb of London.

In 1812, an Act of Parliament was passed allowing Sydenham Common to be enclosed. The common was divided into plots which were then awarded to those who already owned land in Lewisham.

In 1809, the Croydon Canal, connecting Croydon with the Thames, was opened with a wharf at Sydenham. However, the canal was not a commercial success and closed in 1836. Its assets were acquired by the London & Croydon Railway, who drained the canal and built a railway line connecting Croydon with London by way of Sydenham and Forest Hill. The railway, opened in 1839, was one of the first passenger lines in England. London was now a mere 14 minutes from Sydenham.

In 1854, the Crystal Palace, which had housed the Great Exhibition of 1851 in Hyde Park, was rebuilt, much enlarged, on Sydenham Hill. Until it burnt down in 1936, the Crystal Palace was one of the most important centres for the arts and entertainment in Europe. The railway allowed people to travel quickly and easily to the Crystal Palace, and on the land that had once been Sydenham Common large villas were built for those who wished to live near this fashionable spot.

Bibliography

Alcock, Joan P., *Sydenham & Forest Hill History and Guide* (Tempus Publishing Ltd, 2005)

Coulter, John and John Seaman, *Forest Hill & Sydenham* (Sutton Publishing, 2003)

Coulter, John and John Seaman, *Sydenham & Forest Hill* (Alan Sutton, 1994)

Coulter, John, *Sydenham & Forest Hill Past* (Historical Publications Ltd, 1999)

Pullen, Doris E., *Forest Hill* (1979)

Pullen, Doris E., *Sydenham* (1975)

Spurgeon, Darrell, *Discover Sydenham and Catford* (Greenwich Guide Books, 1999)

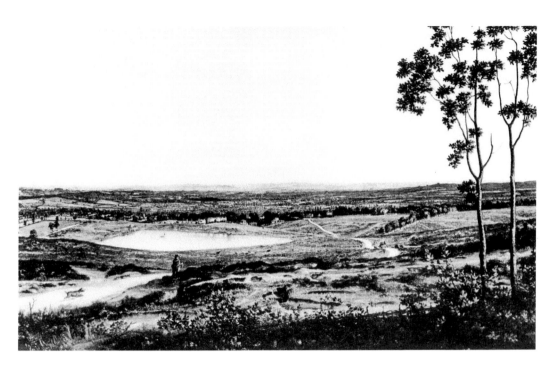

Sydenham Common, 1812

This view of Sydenham Common was painted by James Pringle. He lived at Bell Green, where his family had a nursery. Pringle was standing at the top of Kirkdale, near the junction with Sydenham Hill. At this time, Kirkdale was a mere track across the common, winding towards the Greyhound. The large tract of water to the left of Kirkdale was the reservoir for the Croydon Canal, now covered by Sydenham Park. On the other side of Kirkdale is an avenue of trees leading to Westwood House. This was already known as 'The Jews Walk'. Sydenham Common covered some 500 acres of Upper Sydenham and Forest Hill. At a time when most land was privately owned, the common was a vital asset, providing an open space where those who owned no land could wander freely, graze livestock, gather firewood, hunt game, hold fairs and even squat in temporary shelters.

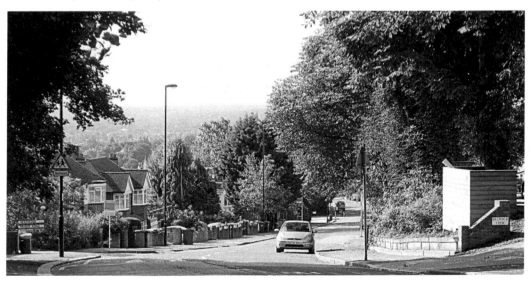

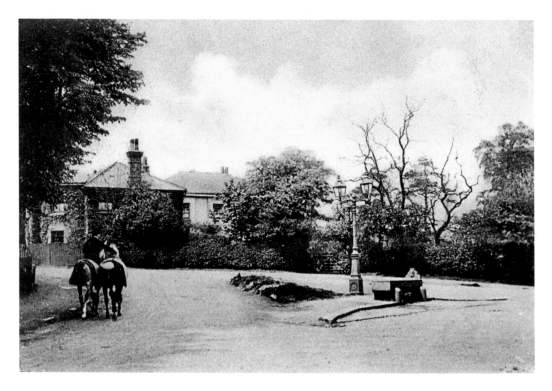

Holly Brow, 1912 and 2014

This view is towards the junction of Kirkdale and Sydenham Hill. There was a short-lived telegraph station on the site around 1819. The original house, painted white and set back, was built in the early nineteenth century. The extension to the left was added in the mid-nineteenth century and around 1934, the original house and the extension become separate residences.

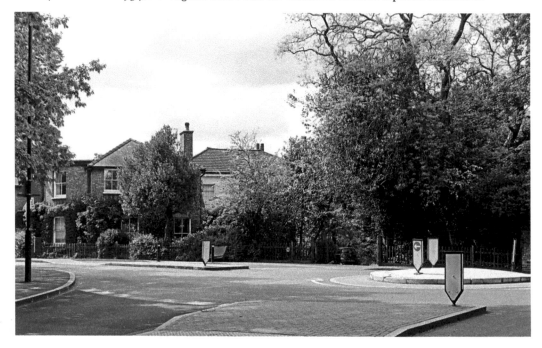

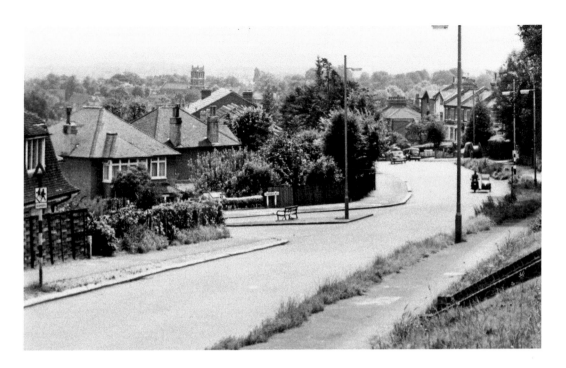

View Down Kirkdale, 1950s and 2014

Thorpewood Avenue is on the left and Mount Ash Gardens on the right. Dilkusha, No. 25 Kirkdale, on the further corner of Thorpewood, was the home of Reginald Harpur from 1939 to 1959. In 1937, Mass Observation was set up to survey and analyse the lives of ordinary people. Reginald Harpur volunteered, with others, to keep a diary from 1940 to 1951, under the name 'Herbert Brush', and kept a detailed account of his daily life. This included tending his allotment in Baxter Field and visits to the Capitol Cinema. Extracts from his diary, and those of other volunteers, were published as *Our Hidden Lives* in 2004.

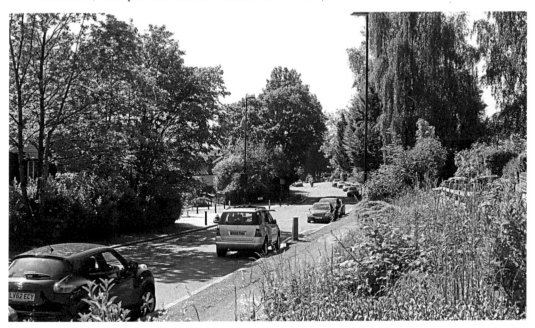

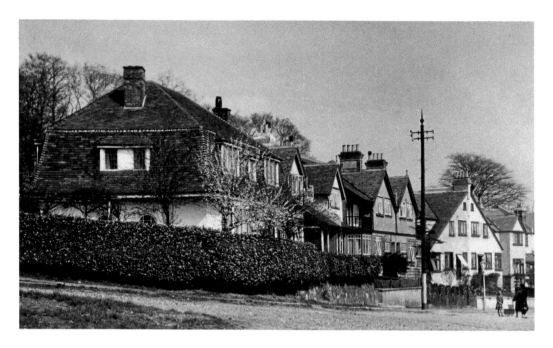

Thorpewood Avenue From Kirkdale, 1930s and 2014

In 1828, James Hunt, a builder, bought a large plot of land bounded today by Kirkdale and Charlecote Grove, including Baxter Field and the upper part of Thorpewood Avenue. He built a large house for himself where Eliot Bank School now stands and called it Woodthorpe. He also built a few houses along Kirkdale and in Charlecote Grove, but most of the land was used as pasture. These houses, Nos 3–17, were among the first to be built in Thorpewood Avenue in 1910. On 29 July 1944, a V1 'buzz bomb' landed at the point where the road bends to the right. A family of three died at No. 22 and houses on both sides of the road were seriously damaged.

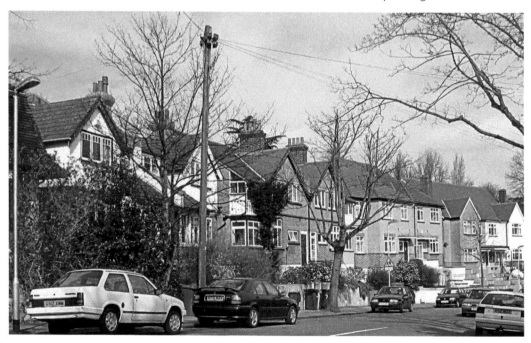

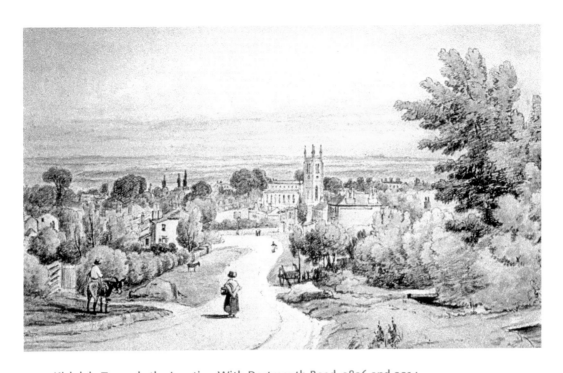

Kirkdale Towards the Junction With Dartmouth Road, 1836 and 2014

This watercolour was painted by Thomas Lound. On the left, by the donkey, is a path that went between the enclosed fields to London Road. Indications of it still survive, particularly the lane from Featherstone Green to London Road, opposite Sainsbury's. Just beyond the lane are two timber cottages, Nos 89 and 91 Kirkdale, which still survive. They were built in the 1830s and are among the oldest surviving buildings in Upper Sydenham. In the distance is St Bartholomew's church, opened in 1831.

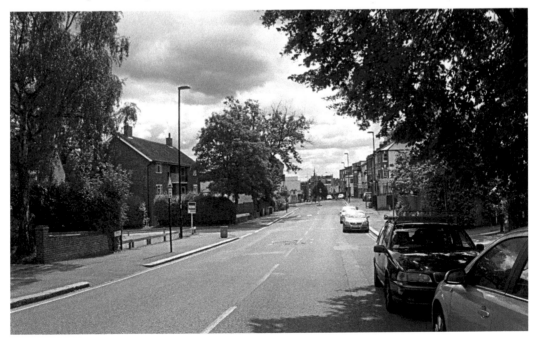

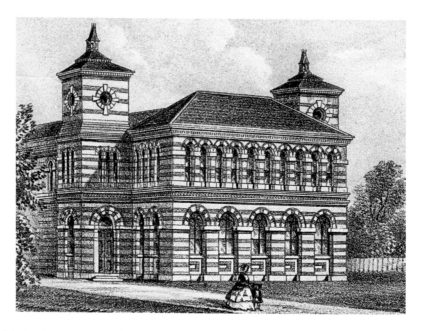

The Kirkdale Institute, 1860 and 2003

This building has had several names, most recently, since it became part of Kelvin Grove School, the Paxton Building. It opened in 1861, but its origins were closely linked with the opening of the Crystal Palace on Sydenham Hill in 1854. John Scott Russell, who was closely involved with the scheme to re-erect the Palace, and Joseph Paxton, architect of the building, discussed their concerns that, for poorer people, the cost of visiting the Crystal Palace regularly for exhibitions, concerts and other activities would be prohibitively expensive. Eventually, on 7 June 1858, Russell, Paxton, George Grove and others formed a committee to build a mechanics' institute in Sydenham, which would include a lecture hall, a reading room and a school. As costs were to be met by voluntary contributions, this flyer was produced, showing Paxton's original design for the building. Insufficient funds were raised, so a shallower building, without the two towers, was erected. The front of the building remained true to Paxton's original plans until 1905, when the London County Council added a ground floor extension across the front and wings at each side. The fact that these were designed by William Flockhart added to English Heritage's enthusiasm for the building when they listed it Grade II in 2011.

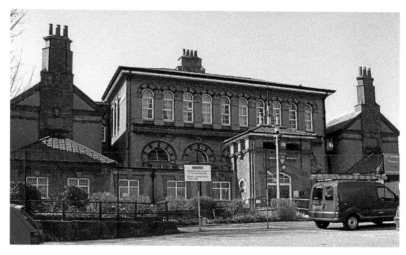

Junction of Dartmouth Road and Kirkdale, 2003 and 2014

This area was among the first to be developed after the enclosure. These buildings began as cottages with shopkeepers and tradesmen doing business from their front rooms. As business developed they added extensions over the front gardens with shop fronts to attract customers. Until the late 1840s, this area was still referred to as 'The Common', but by 1850 it was High Street, Sydenham from the Bricklayers Arms to the Fox and Hounds. It only became Kirkdale and Dartmouth Road on 1 January 1937.

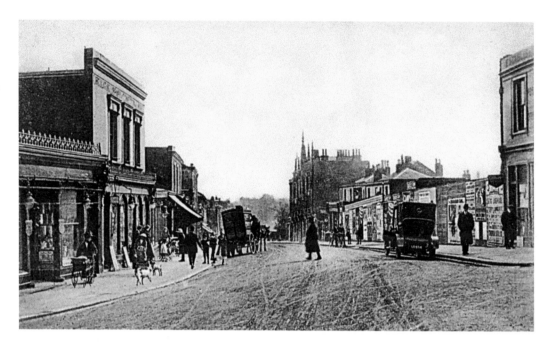

Kirkdale Towards High Street Buildings, 1910 and 2014

The poster on the right for *Quaker Girl*, a comedy that opened at The Coliseum in 1910, helps date the picture. On the extreme right, on the corner of Halifax Street, is a building that survives. It opened before 1847 as a grocer's and post office owned by Benjamin Boucher. The post office was still run by the Boucher family until the 1960s. Sydenham Court was to be built in the space behind the hoarding in 1936. During the war, the name was changed to Denham Court, perhaps to confuse any invading Germans. The large building opposite, No. 107 Kirkdale, was a bookseller and printer from at least 1858 until 1941. It has lost some of its decorative features and is now a food and wine store.

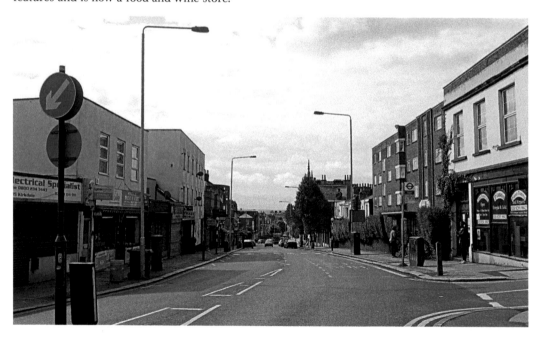

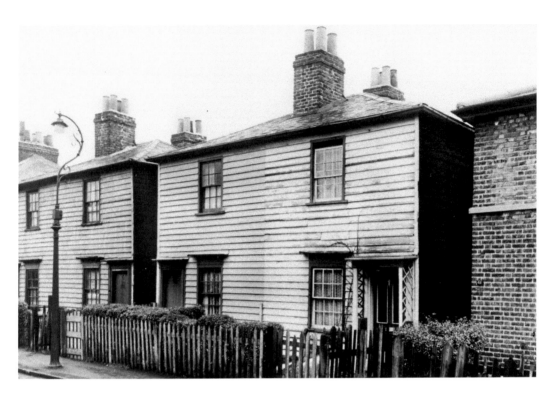

Willow Way, Around 1962 and 2014

Willow Way was originally part of a willow-lined footpath that wound round the Croydon Canal reservoir. The western side of Willow Way was developed first, in the 1820s, and the houses would have looked out across the footpath to the reservoir. After the reservoir was drained in the late 1830s, the eastern side of Willow Way could be developed. These two pairs of timber cottages, Nos 33–39 Willow Way, were the first to be built on this side of the road. They were demolished in the 1960s.

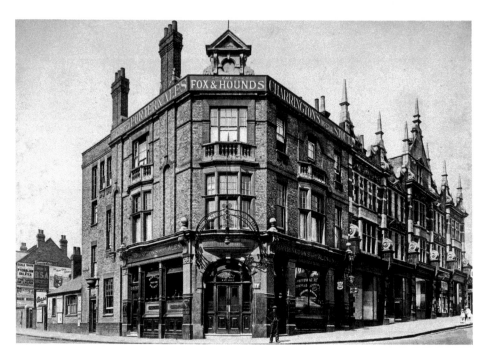

The Fox and Hounds, 1913 and 2014

From around 1769, there was a Fox and Hounds at Peak Hill, on the edge of the Sydenham Common. It was a couple of hundred yards from the Greyhound and both names apparently refer to The Old Surrey Foxhounds who would have met at one or the other of the pubs before setting off to hunt foxes. The Fox and Hounds opened on the present site around 1826. In 1889, the newly appointed landlord, Edward William White had the pub rebuilt to the designs of Thomas Halliburton Smith. It is now called Fox's. In 1896, Alexander Robert Hennell, who lived in Mayow Road and also designed Forest Hill Library, was appointed to design the terrace of shops on the remainder of the site, beside of the new pub. These were called High Street Buildings and in 2008 were listed Grade II by English Heritage.

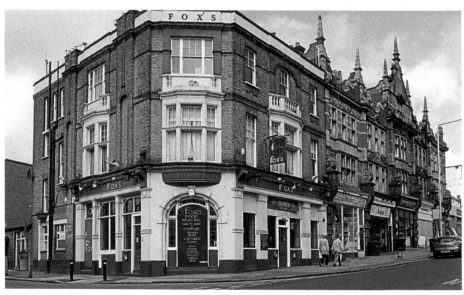

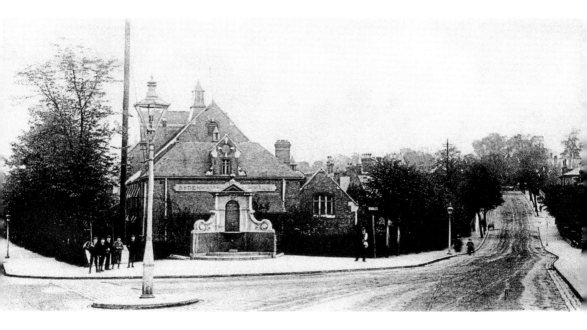

Jubilee Memorial Fountain and Jews Walk, Around 1904 and 2014

The original building on this site was Fir Lodge College, the first school of Ernest Shackleton and novelist A. E. W. Mason before they went to Dulwich College. Fir Lodge was demolished in 1896 and in 1897, the Sydenham Public Hall, a theatre and concert hall, was built. It was not a success and closed in 1903. The National Telephone Company, which had been operating a telephone exchange at No. 157 Kirkdale from around 1894, acquired the building and until 1928 it was the Sydenham Telephone Exchange. A new Sydenham Exchange was built at the end of Lawrie Park Road and this building became the PO Telephones Training School. This closed around 1988 and Homewalk House was built on the site. While the hall was being built, the owners agreed to let the Board of Works have a small part of their land on the corner of Jews Walk to build a fountain to celebrate Queen Victoria's diamond jubilee in 1897. The fountain was designed by Alexander Robert Hennell.

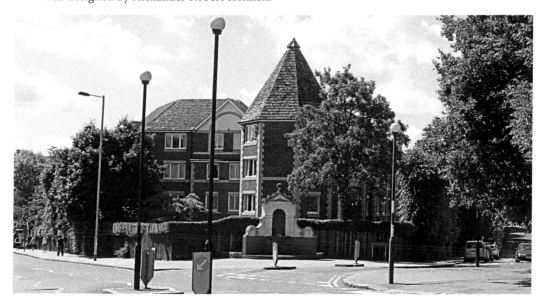

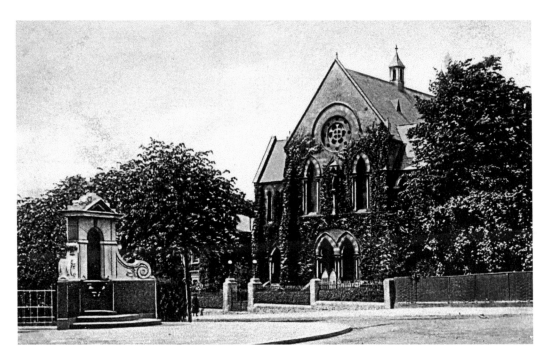

The Congregational Church in the Grove, Around 1912 and 2014

The church was built in 1867. Since the late 1850s, some residents had been referring to Jews Walk as 'The Grove' and in 1878 they applied to the Metropolitan Board of Works to have the name formally changed. The Board, to their credit, decided that it would not be changed and so one of Sydenham's oldest, and more interesting, street names survived. In 1972, the Congregationalists merged with the Baptists, whose church was on the corner of Derby Hill. Both original churches were demolished and replaced by the present Grove Centre church in 1974.

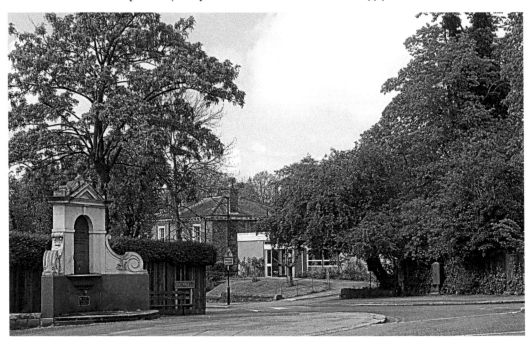

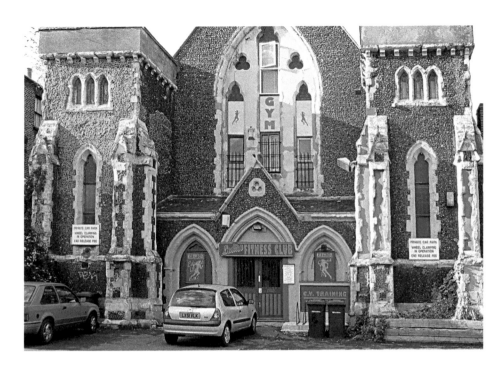

Park Hall, Sydenham Park, 2002 and 2014

Built around 1850 as the Sydenham Park chapel, the building was faced with knapped flint, a very unusual material in this area. The back wall of The Woodman, in Kirkdale, is perhaps the only other local example. In 1867, the Congregationalists built the church in the Grove and this building was renamed Park Hall and used as a Sunday school. Later it was used for public meetings and coroners' inquests. In 2010, the flint was rendered over.

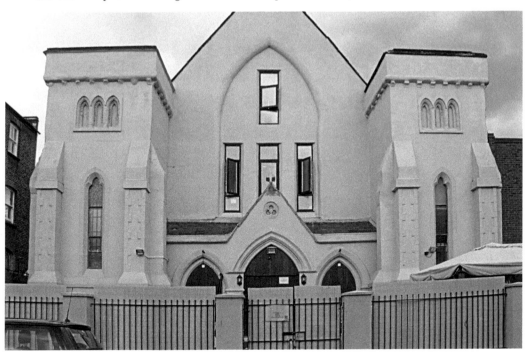

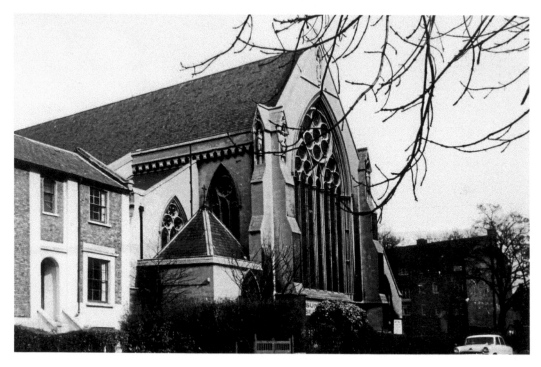

Holy Trinity Church, Sydenham Park, Around 1970 and 2014

The church was opened in 1866. The first incumbent was the Revd Henry Stevens, who was instrumental in founding Holy Trinity Church School. He had previously been the incumbent at the Episcopal chapel on the corner of Trewsbury Road. He remained the minister at Holy Trinity until his death in 1901. The church was demolished in 1976 and a block of flats built on the site. The statue in front of the flats is all that survives of the church.

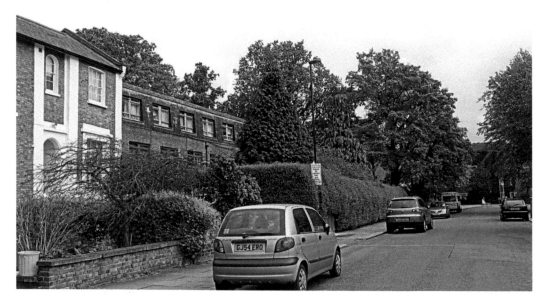

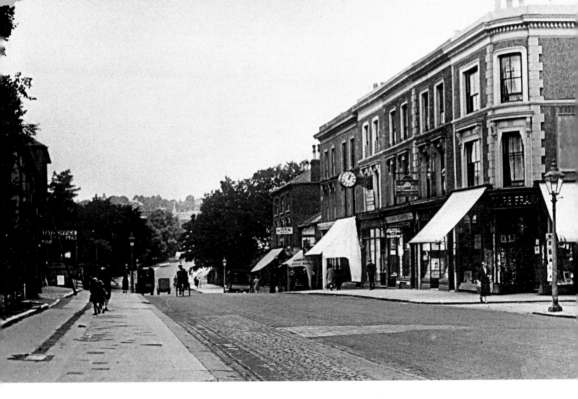

Kirkdale with Peak Hill Avenue on the Right, Around 1928 and 2014

Originally, Kirkdale ran from Cobb's Corner to Wells Park Road. Beyond that was High Street, Sydenham and then, to the top of the hill, Sydenham Hill Road. In 1937, the whole road became Kirkdale. The Victoria Wine Company began trading from the shop at the far end of the terrace around 1875, just eight years after the company opened its first shop in the City of London in 1868. Around 1942, they moved down to Sydenham Road. Beyond is Shaw Bros. In 1911, they were coachbuilders and in 1912, they were also car repairers. They were still in business in 1969. During the war the terrace was struck by a V1 rocket and suffered serious damage.

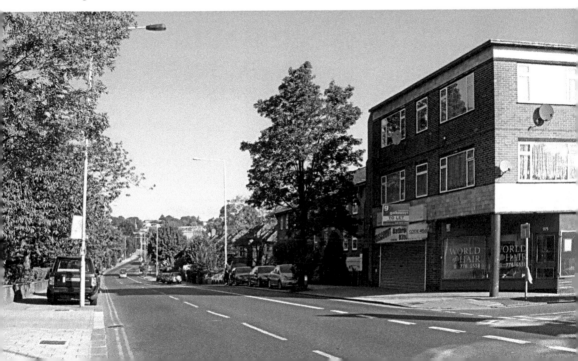

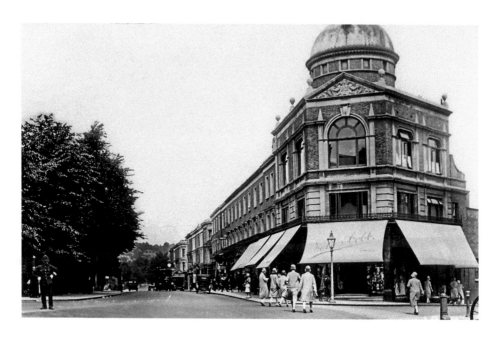

Cobb's Corner, Kirkdale, Around 1926 and 2014

Walter Cobb opened his linen drapers' shop in 1860 at No. 301 Kirkdale, on the present site of the Citizens' Advice Bureau, and called it Regent House. Over the years he expanded into the shops on either side until, by 1898, Cobb's Department Store occupied almost the whole terrace. The shop on the corner of Peak Hill, now Spring Hill, had been a butcher's shop from around 1871. While Cobb was extending his store, he must have coveted this prime site, and when the butcher finally retired in 1900, Cobb lost no time in demolishing the shop and building this grand entrance to his department store. The block on the left that included Kirk's Cameras, now an estate agent, was built in 1936 to the designs of Marshall and Tweedy.

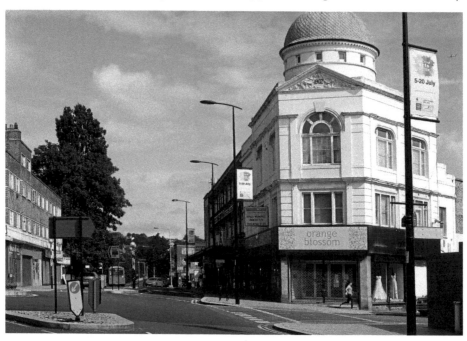

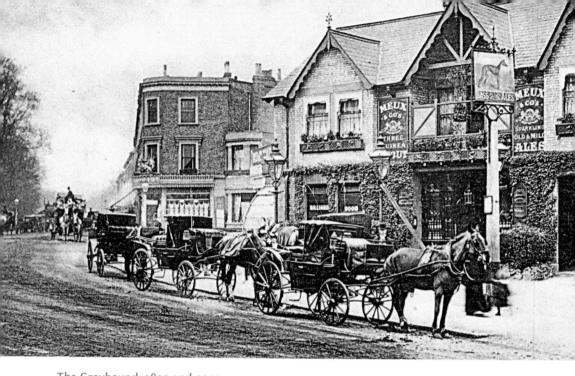

The Greyhound, 1899 and 2014

Beyond the Greyhound is the butcher's shop that Walter Cobb was about to acquire. When the Greyhound was built here around 1726, it was on the edge of Sydenham Common. This was where the Old Surrey Fox Hounds sometimes met and where visitors to Sydenham Wells could stay. This prominent extension to the earlier buildings was completed in 1873, when the pub became The Greyhound Hotel, with a spectacular tiled corridor leading to the hotel reception desk. The Greyhound continued to thrive into the 1980s, when it was a popular comedy venue with the Rub-a-Dub club, hosted by Vic Reeves and Bob Mortimer, and the likes of Frank Skinner, Jo Brand and Alan Davies performing. In 2014, The Greyhound barely survives and the future of what little is left is still in doubt.

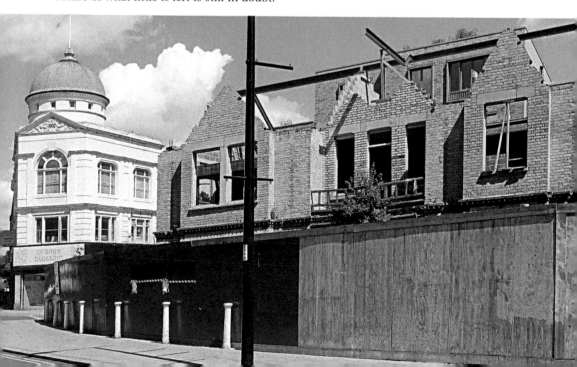

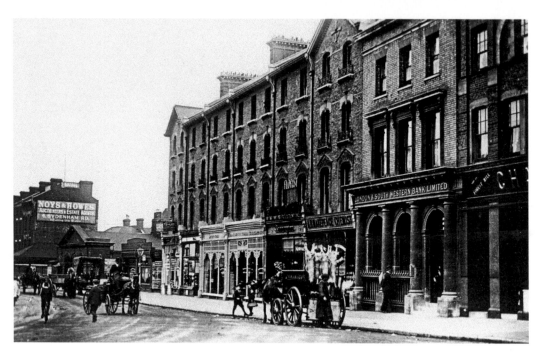

Nos 260–274 Kirkdale, Around 1906 and 2014

The terrace from Nos 264–274 Kirkdale was built in 1875. At that time, Daniel Harris opened a pharmacy at No. 264. Around 1901, Arthur Benedict Makepeace took over the pharmacy and the shop retained his name until a couple of years ago. Kirkdale Bookshop began trading at No. 272 in 1966 and has become one of south-east London's most important and successful bookshops. The London and South Western Bank, later Barclays and more recently the Lewisham Credit Union, opened for business on 1 January 1876. Its first manager was Theophilus William Williams, Lewisham's first, and subsequently disgraced, mayor.

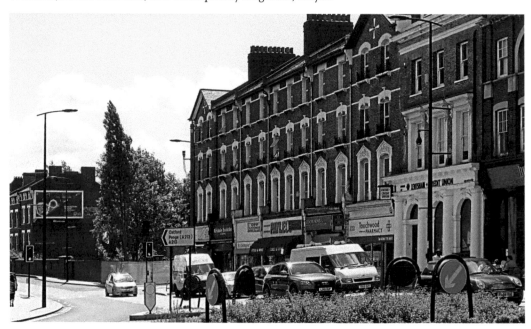

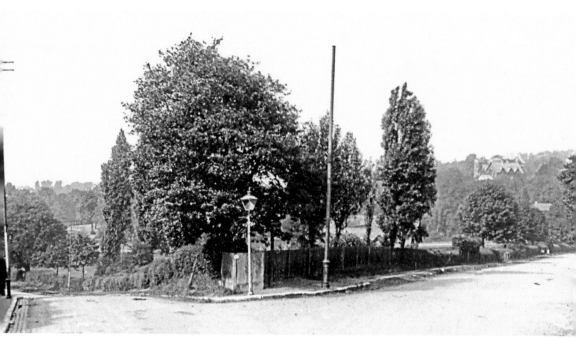

The Horniman Triangle, Around 1910 and 2014

Sydenham Hill is on the left and Sydenham Rise to the right. The triangle, like the houses along Sydenham Rise, is part of the Dulwich Estate. The boundary with Lewisham at this point is marked by Eliot Bank, which also marked the boundary between Kent and Surrey. From the 1870s, the triangle was a smallholding with a cottage at the top. After the Second World War, the Dulwich Estate leased the triangle to the London County Council as an extension to Horniman Gardens and, in 1954, the LCC formed a children's play area with sandpit, paddling pool and café. The spoil from this work was used to create a series of banks and pits where children could play on their way from the pool at the bottom of the field to the sand pit at the top. There was, at the entrance, a notice banning adults unless accompanied by a child! The gabled house on the hill beyond Sydenham Rise is Surrey Mount, F. J. Horniman's house.

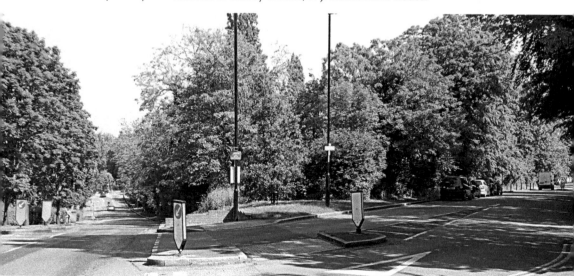

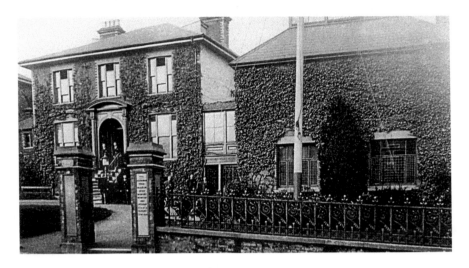

Horniman Museum, Around 1896 and 2014

After his marriage to Rebekah Emslie in June 1859, Frederick John Horniman moved to a house, since demolished, at the top of Derby Hill. Their two children, Annie and Emslie, were born there and it was at this time that Horniman began collecting. In 1866, the family moved to Grassmount, Taymount Rise and in 1868, they moved to Tarvin House, No. 100 London Road (the previous owner was Julius Caesar, a City merchant). Horniman changed the name to Surrey House as the border between Kent and Surrey ran along the eastern edge of the garden. In this picture, Surrey House, is on the left. While here, Horniman's collecting became really serious. By 1881, he had bought a larger house at the top of the hill, called The Keep. In 1890, Horniman opened Surrey House to the public as a free museum. The present building was designed by Charles Harrison Townsend. When the foundation stone was laid on 16 November 1898, it was in Camberwell, but by the time the museum opened in 1901, the boundary had been changed and the museum was in Lewisham.

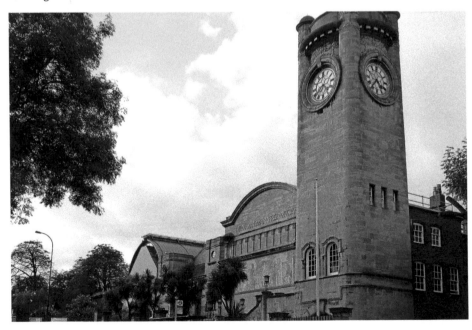

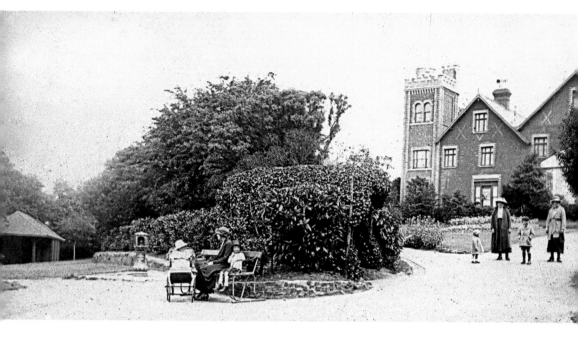

Surrey Mount, Horniman Gardens, Early 1920s and 2014

The Keep was built in the early 1850s at the end of the long drive rising from London Road. Again Horniman changed the name, this time to Surrey Mount. He and his family moved permanently to Surrey Mount in 1888. When the museum and gardens opened in 1901, Surrey Mount was used as the tearooms and for storage. Damaged during the war, the house was eventually demolished in 1960. On the left is the Dutch Barn, built for Horniman around 1895. The barn was originally thatched and was probably used as a summerhouse.

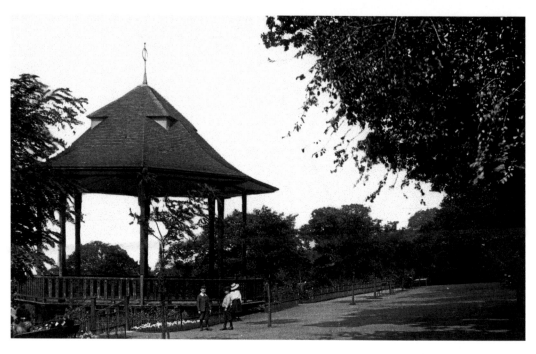

The Bandstand, Horniman Gardens, Around 1906 and 2014

Designed by Charles Harrison Townsend in 1903, the bandstand has recently been given a new lease of life, which includes the restoration of the weather vane. The spectacular views beyond, which for decades had been partially masked by screens, have now been restored with new glass panels evoking the bandstand's heyday a century ago.

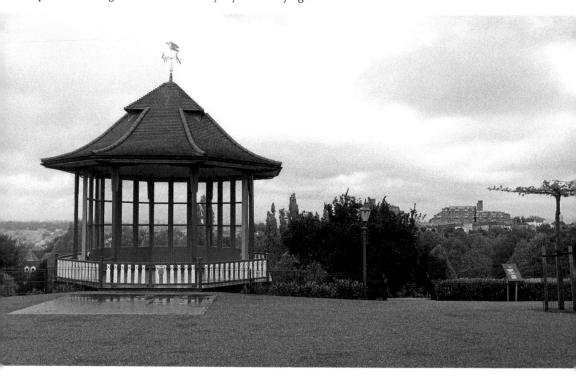

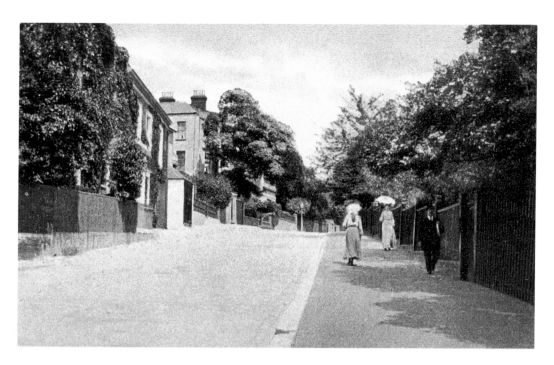

Honor Oak Road from Westwood Park, Around 1910 and 2014
This view shows Honor Oak Road from just past the junction with Westwood Park. Two centuries earlier, the road was little more than a track from Peckham ending at this point, on the edge of Sydenham Common. During the early 1790s, several houses were built along the road and in 1794 one of them, described as 'at Forest Hill', came up for auction. This was probably the first reference to Forest Hill, which, until the early 1840s, referred just to this part of Honor Oak Road. Hill House, on the left, was one of the first houses to be built and was in a prime position overlooking the common

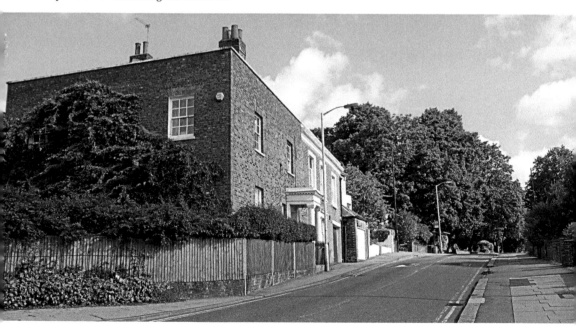

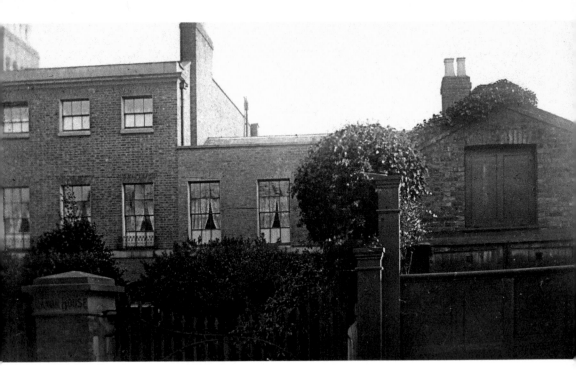

The Manor House, No. 53 Honor Oak Road, Around 1910 and 2014

The Manor House was built around 1815. From 1920, Florence Beatrice Rainbird was living here. In 1925, she married Charles Augustus Bynoe, a surgeon with a colourful career. In 1892, he was convicted of forging banknotes, for which he served nine years in prison. On his release, he campaigned vigorously to have the conviction overturned, without success. The Bynoes moved away in 1930 and by 1932, the Manor House had been converted to thirteen flats, probably by Ted Christmas.

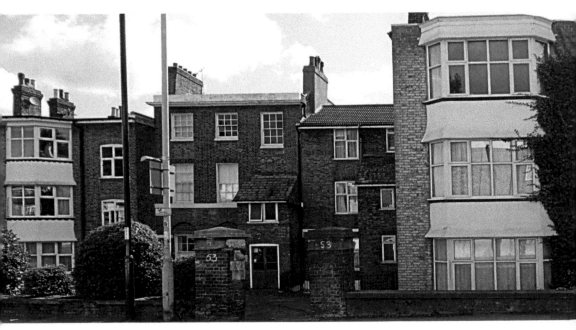

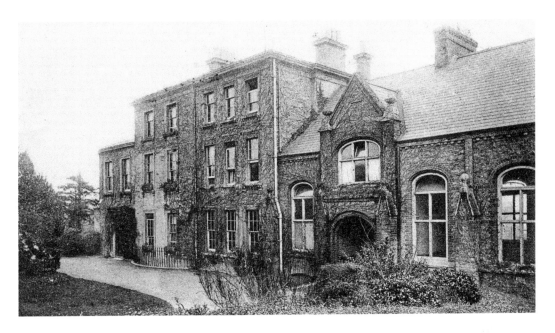

Forest Hill House, Honor Oak Road, Around 1910 and 2014

This is another of the early houses in Honor Oak Road. The central block was built by the 1790s. In 1886, the house became the Forest Hill House School and at around the same time, a single-storey hall was added to the right. The school had a number of distinguished pupils, including H. M. Bateman, the cartoonist, who left around 1903 to go to Goldsmiths' College to continue his studies in drawing and painting. In 1926, the school moved to Manor Mount. They were followed at Forest Hill House by the Christian Fellowship and Conference Centre, founded by the charismatic Theodore Austin-Sparks. Revd Austin-Sparks was the minister at the Baptist church on the corner of Derby Hill and Dartmouth Road until 1926 when he decided to form his own ministry with a conference and training centre. Austin-Sparks died in 1971 but still has a strong international following.

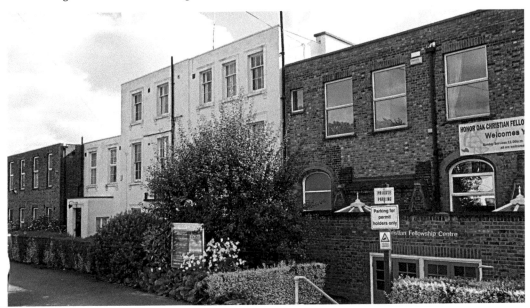

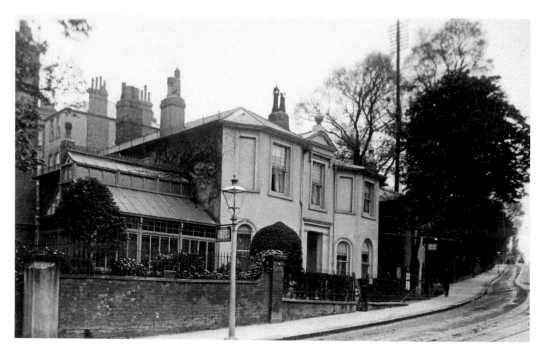

White Lodge, No. 87 London Road, Around 1912 and 2014

This was one of the first houses in London Road, probably built during the 1830s. William Whittell, a brick maker and builder, was living here in 1841 and may well have built the house for himself. He also built the original villas on either side of Taymount Rise, later converted to flats by Dorrell Bros. Around 1910, White Lodge was divided into two flats. On 16 September 1940, a bomb landed on No. 85 London Road, behind White Lodge. It destroyed two buildings and killed nine people. White Lodge was seriously damaged by the blast and was largely rebuilt.

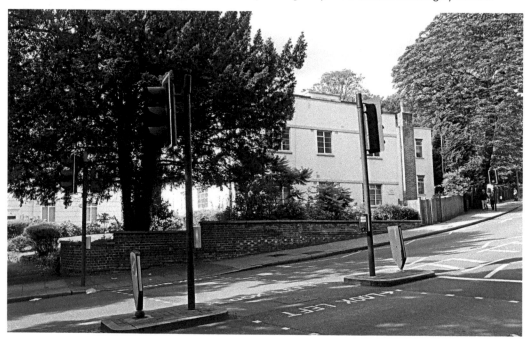

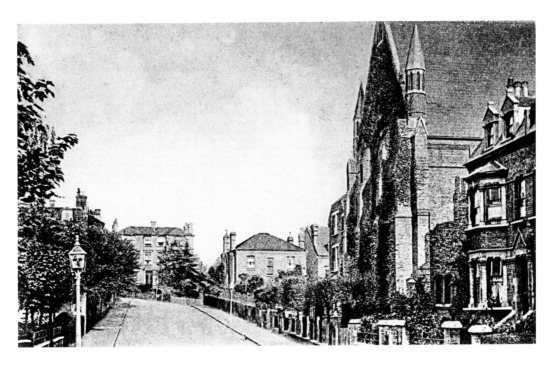

St Paul's Church, Waldenshaw Road, Around 1906 and 2014

St Paul's began in a temporary iron building in Manor Mount around 1876. In 1882, work began on this very large church in Waldenshaw Road. The church could accommodate at least 900 people although the parish had a population of just 678. Between 1876 and 1877, the composer John Henry Maunder was the organist. At the same time, the sidesman was Admiral Sir George Richards, who lived in Dacres Road and was aide-de-camp to Queen Victoria. The church was bombed in 1944 and although the damage was not serious, the congregation decided to meet elsewhere. Eventually the parish merged with St George, Perry Hill. In 1969, the site in Waldenshaw Road was sold to the GLC, who built an annexe to Fairlawn School.

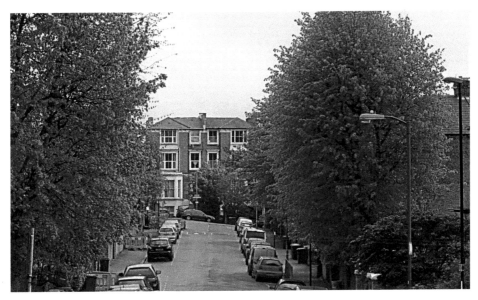

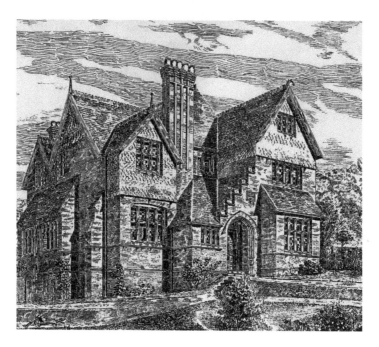

St Paul's Vicarage, No. 8 Manor Mount, 1883 and 2003

Although St Paul's church no longer exists, the original vicarage does. It was designed, like the church, by Edward Mountford and Herbert Appleton and built in 1883. The house ceased to be St Paul's vicarage in 1902 when it became a private house called The Nook.

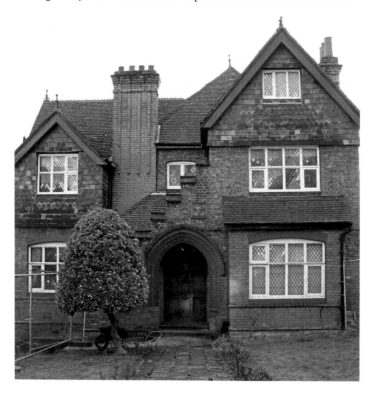

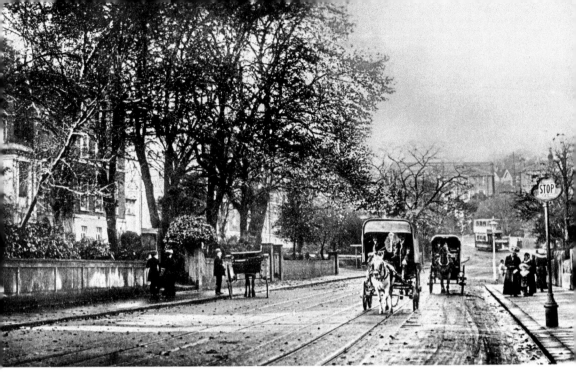

London Road, Around 1908 and 2014

Taymount Rise is on the left and Waldenshaw Road on the right. The flats on either side of Taymount Rise were originally large Victorian villas, called Prospect Villas, which extended down to the junction with Dartmouth Road. They were built from the late 1840s as a direct response to the opening of Forest Hill station. Apart from the buildings on either side of Taymount Rise, the only other survivors of Prospect Villas are Kings Garth and Princes Garth and No. 5 London Road, behind the estate agent. The villas on either side of Taymount Rise were converted to flats by Arthur and Henry Dorrell, who set up their business in London Road around 1891. It is still possible to see where the original stairs were, leading up to the first floor front doors, with the surviving columns which would have supported the porches.

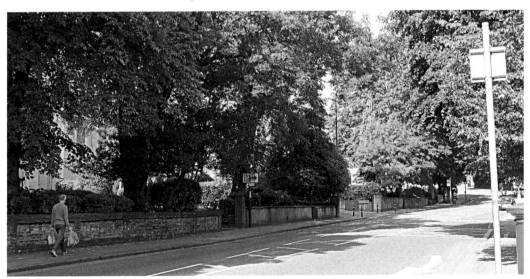

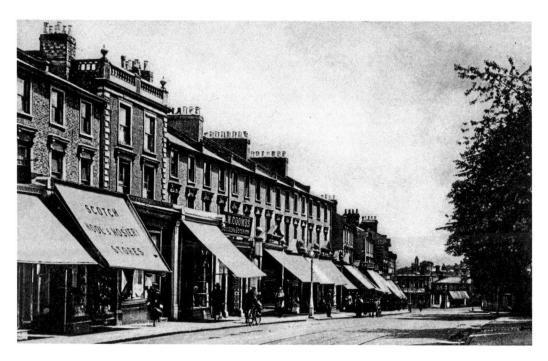

London Road, Towards the Station, Around 1912 and 2014

Whittington Terrace, the group of shops on the left, was built around 1864. The Scotch Wool & Hosiery Store was at No. 50 London Road, now the optician's. This section of Whittington Terrace, Nos 50–58 London Road, still survives fairly intact. The rest has been replaced by Sainsbury's, which began trading from this site in 1965. Arthur William Coombs, a little way along on the left, was a builder and decorator who traded from No. 44 London Road from around 1891. He built Nos 60–64 London Road in 1904 and lived at No. 64 until his death in 1934. His house has an inscription, 'F.M.C, A.W.C, R.M.C, 1904'. These were his own initials, his wife, Rose Mary's, and his sister, Flora Mary's. On the right, Imperial Buildings, Nos 45–57 London Road, were built around 1900 by Dorrell Bros.

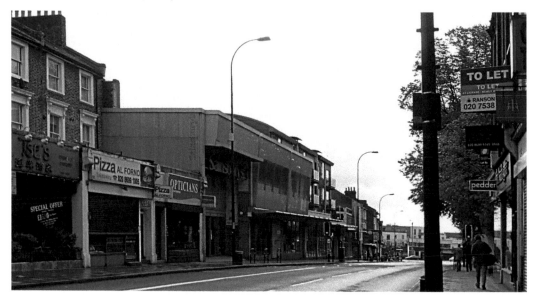

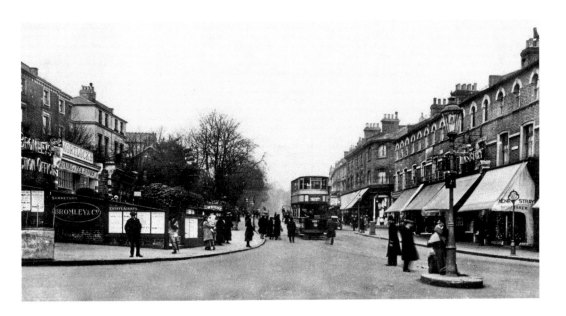

View Up London Road, Early 1920s and 2014

When this section of the tramline from Victoria, along Lordship Lane, opened in December 1908, it terminated at the end of London Road, opposite the station, as the corners into Devonshire Road and under the bridge were too sharp for the trams to negotiate. It was not until 1915, when Nos 2–4 London Road were demolished and the corner widened, that trams could continue under the bridge. To the right of the lamppost is Sainsbury's original shop in Forest Hill, opened in 1906. By 1933 they were also using the Red Cross shop next door, where several distinctive features survive. Forest Hill's grandest cinema, the Capitol, was designed by Stanley Beard and opened in February 1929. The cinema closed in October 1973. Plans to build shops and flats on the site were strongly opposed and finally, in 1978, the building was saved when Mecca opened the Jasmine Bingo Hall. This closed in the mid-1990s and, fortunately, the building was listed Grade II in 1993. In 2001, The Capitol reopened as a pub.

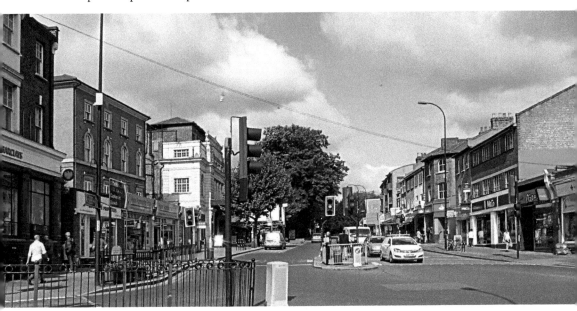

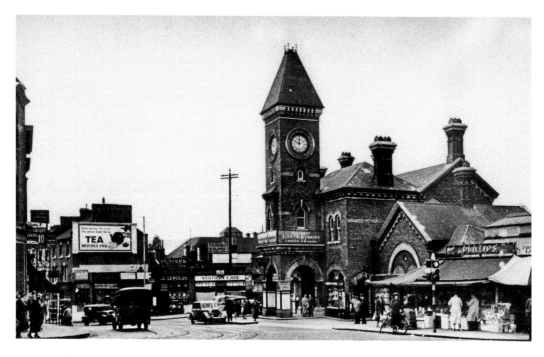

Forest Hill Station, 1938 and 2014

The London and Croydon Railway, from London Bridge to what is now West Croydon, opened in 1839, one of the earliest passenger railways in the country. The station at Forest Hill was originally called Dartmouth Arms as, at that time, Forest Hill was still just a few villas along the upper part of Honor Oak Road and the Dartmouth Arms was the only building of any significance near the station. The present building is the fourth. The third, and by far the grandest, opened in 1883. In 1944, a V1 fell on the station underpass, killing three people and damaging the station and other buildings. The station was patched up and continued in use until the early 1970s, when it was replaced by the present undistinguished ticket office.

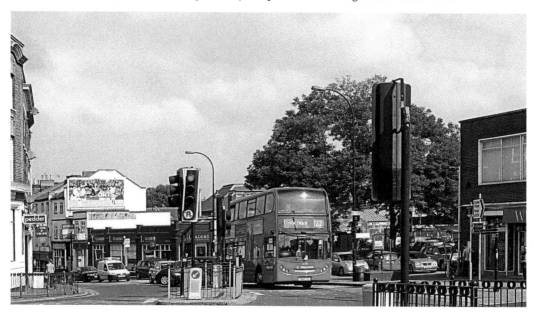

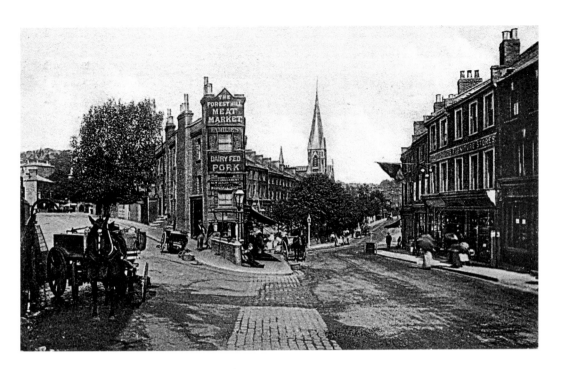

Devonshire Road, Around 1906 and 2014

Davids Road is on the left. The Forest Hill Meat Market had traded here from 1884, but was forced to move in 1915 as part of the road widening for the trams. It re-opened at Nos 3–5 Devonshire Road, opposite the station, where the name still survives under the modern fascias. William Chard opened his pawnbrokers at No. 10 Devonshire Road in 1882 and the shop continued trading until 1938. In 1904, Chard moved to No. 139 Perry Vale, one of the new Christmas houses, with his daughter, Hilda, and persuaded Ted Christmas to call the house 'Hildaville'.

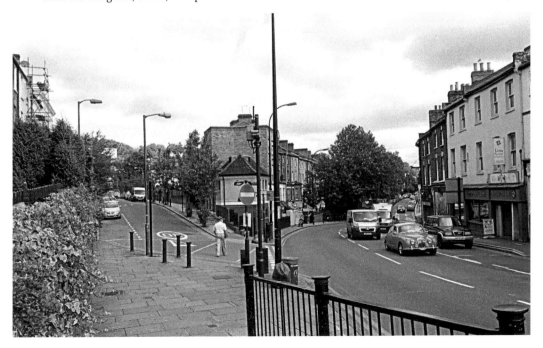

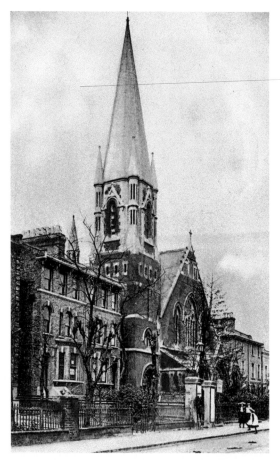

St John's Presbyterian Church, Devonshire Road, Around 1906 and 2014
The church began in 1870 with a meeting arranged by F. J. Horniman at Surrey House. A corrugated-iron church was built in Devonshire Road in 1871 with a rather grand church hall and manse behind, on Davids Road. The hall and manse were designed by Albert Vicars, a local architect who was living in Devonshire Road at the time. The church was destroyed by fire on 17 December 1882 and replaced in 1884 by a Gothic style church designed by John Theodore Barker. Although the church was demolished in 1983, the hall survives, backing onto Davids Road, as does the manse. There is a memorial stone on the hall which was laid by F. J. Horniman on 6 April 1874.

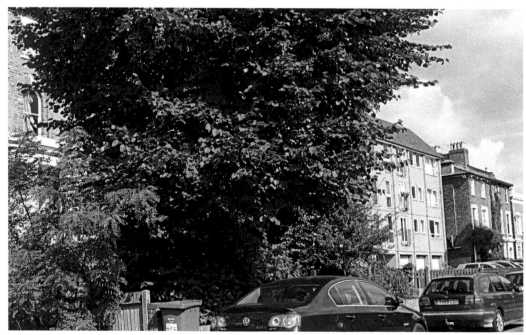

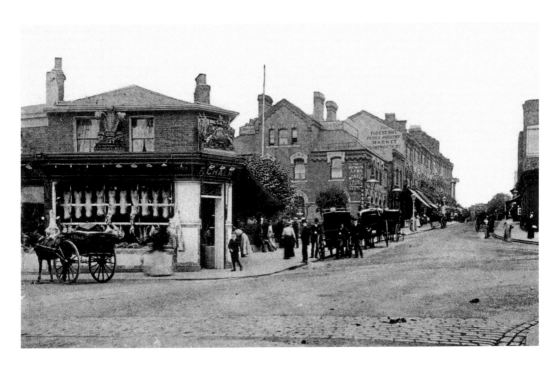

Dartmouth Road, From the Station, Around 1902 and 2014

The butcher's shop was seriously damaged by the V1 that fell on the subway in 1944. It was rebuilt and continued as a butcher's shop until the 1980s. The Dartmouth Arms opened on this site around 1814. It was originally on the bank of the Croydon Canal and was intended to serve the needs of those travelling on the canal. It was rebuilt in 1867. At the same time, the terrace of shops at Nos 11–27 Dartmouth Road was built on the site of the original pub and stables.

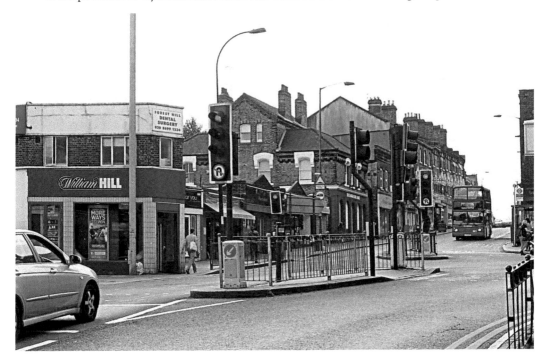

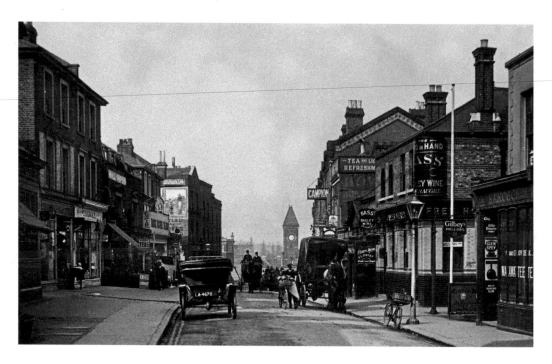

Dartmouth Road Towards the Station, 1913 and 2014

On the left, just past the car, is the Empire Picture Theatre. Opened in 1910, this was Forest Hill's first cinema. Wok Express now occupies part of the building. The cinema only lasted for a few years, closing in 1914. The hall, at the back of the building, survived until a few years ago. The Bird in Hand, opposite, may have been built around 1820, although it has been much altered. It was first licensed as a pub around 1845.

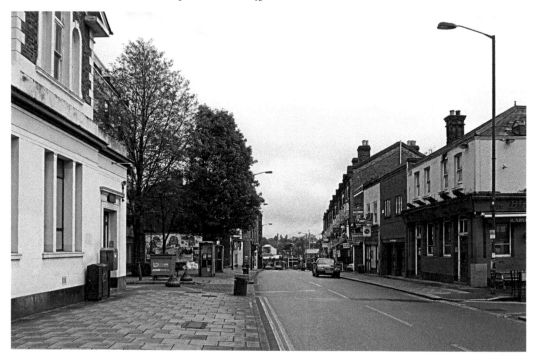

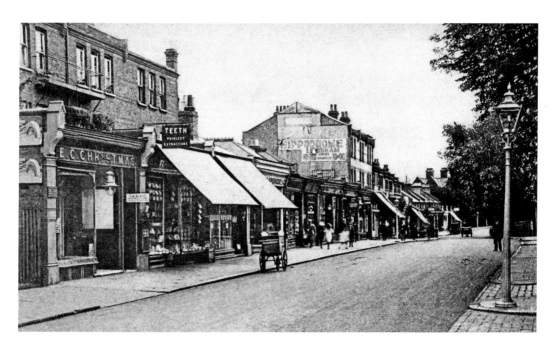

Dartmouth Road from Derby Hill, Around 1908 and 2014

Ted Christmas was a prolific local builder from around 1900 until the 1930s. His father, Edward, a jobbing gardener, was living in Forest Hill above a stable in Taymount Rise by 1867, when Ted was born. Ted trained as a carpenter and by the time he was twenty-one was running his own business from a cottage at No. 55 Dartmouth Road. In 1900, he built this terrace on the site of the cottages at Nos 55 and 57 Dartmouth Road. His wife, Laura, laid the foundation stone, which can be seen in the alley at the side of the terrace. The buildings are little changed, although Christmas's own shop lost its front in 2001. Behind the trees on the right, on the site of Kingswear House, was a large house called Newfield, where Ted Christmas lived between 1913 and 1935.

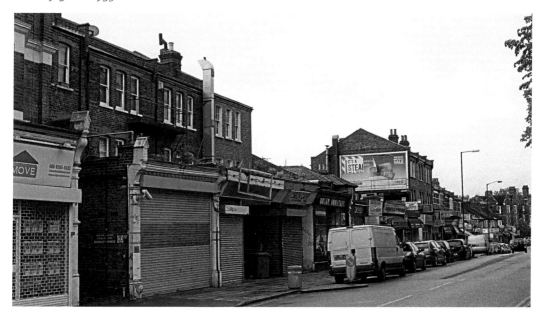

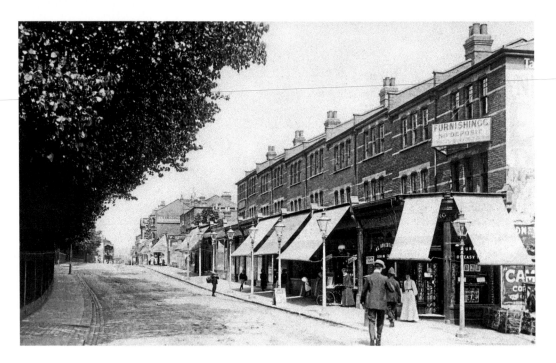

Dartmouth Road Towards Forest Hill, Around 1908 and 2014

This terrace was also built by Ted Christmas around 1901. The Forest Hill Furnishing Company, on the corner of Clyde Vale, opened around 1904, and it is still just possible to make out 'Furnishing Co.' between the first and second floor windows. Similarly, at No. 71 where the *Forest Hill & Sydenham Examiner*, later the *South London Advertiser*, was published from 1906 to 1937, it still proclaims 'Examiner Printing Works'.

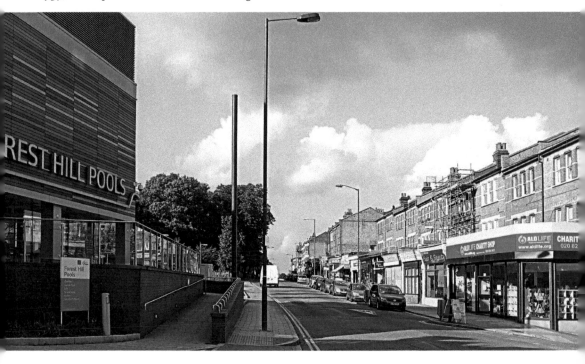

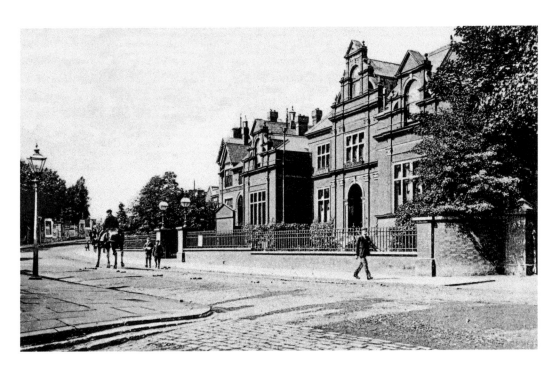

Forest Hill Pools, Dartmouth Road, Around 1906 and 2014

The pools, Louise House, the library and Holy Trinity School were all built on a single large field that was awarded to the vicar of Lewisham when the Common was enclosed in 1819. For over fifty years, the field, known as Vicar's Field, was let as allotments to local people as some sort of compensation for their loss of the common. In the early 1870s, it was decided that there was a need for a church school 'to promote the religious education of this parish'. Holy Trinity National School opened on 26 March 1874. Gradually, with the approval of the church, the lower part of this field fronting Dartmouth Road was built upon. Forest Hill Pools was the next building, opened by the Earl of Dartmouth in 1885. The architect, Thomas Aldwinckle, lived in Forest Hill for most of his working life. Between them, the new buildings offered local people opportunities for learning, healthy exercise and cleanliness, important Victorian values. Three of these buildings, Holy Trinity School, Forest Hill Library and Louise House, have been listed Grade II.

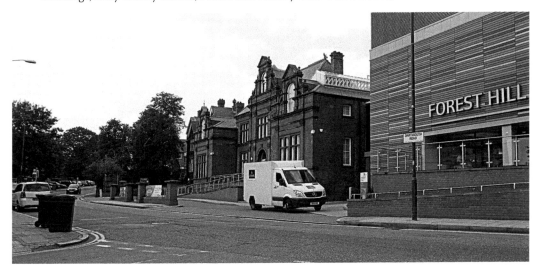

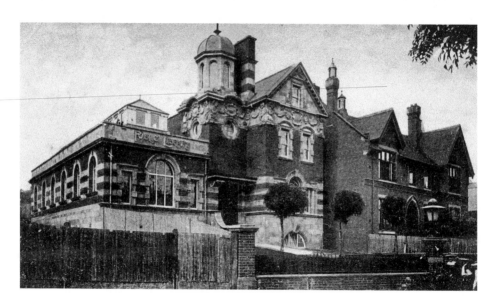

Louise House and Forest Hill Library, Around 1905 and 2014

The foundation stone of Louise House, The Girls' Industrial Home, was laid in 1890 by HRH Princess Louise, daughter of Queen Victoria. The school was funded by voluntary contributions and one of the most generous donors was F. J. Horniman, who gave an annual sum sufficient to support one child. Perhaps the most important person connected with Louise House was Janusz Korczak, a Polish Jew from Warsaw. He visited it in 1911 and was impressed by the experience, and on his return to Warsaw he founded a similar home. He believed that the role of a parent or a teacher was not to impose goals on children but to help them discover their own. He also believed that children had the same rights as adults and their views had equal weight. Both children and staff agreed on the rules. In 1942, Korczak, 192 children and the staff were rounded up by the Nazis. They all died in Treblinka extermination camp. Korczak was given several chances to escape but refused to abandon his children. The final building on Vicars Field, Forest Hill Library, was designed by Alexander Robert Hennell and opened in 1901.

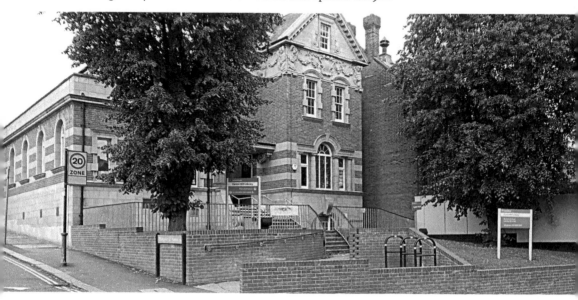

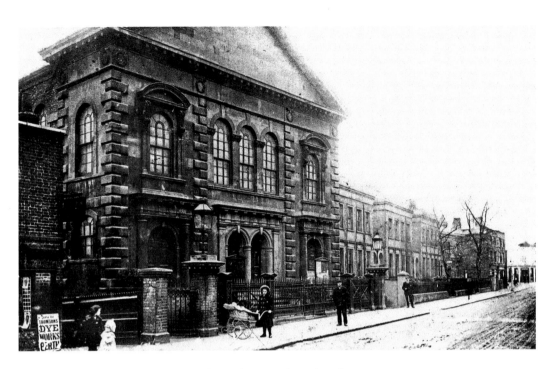

The Wesley Chapel, Dartmouth Road, Around 1906 and 2014

When built in 1849, the original Wesley chapel was described as a 'neat little building'. This was rebuilt in much grander style in 1863. The church and terrace of shops to the left were demolished in the 1960s, when Suncroft Place was built. The villas beyond the chapel, originally called York Terrace and now Nos 165–175 Dartmouth Road, were also built around 1849, on the edge of the recently drained canal reservoir. On the extreme right is the Bricklayers Arms before it was rebuilt in 1924.

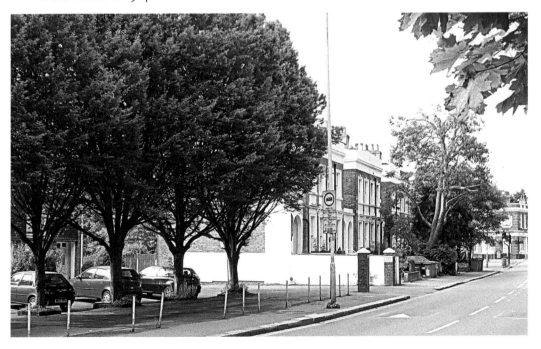

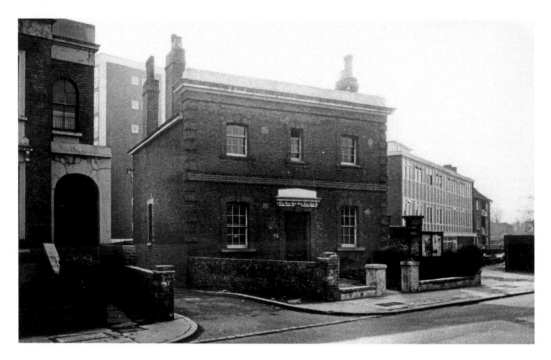

Sydenham Police Station, Around 1964 and 2014

The original police station opened in 1848 and was, until its demolition around 1965, one of the earliest purpose built police stations in the country. It was built at the boundary between the large villas of Sydenham Park and Upper Sydenham and the poorer, rather overcrowded cottages along Willow Way, the High Street and Wells Park Road. A new police station was built in 1963, and was closed in 2014. For the first time in over 150 years, we do not have a local police station. The tall building behind the original station was the police Section House, providing accommodation for the officers. It is now Miriam Lodge, a hostel for homeless people.

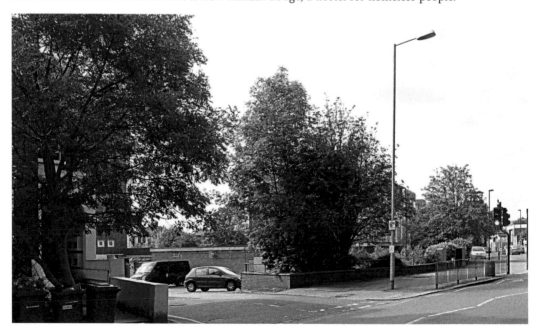

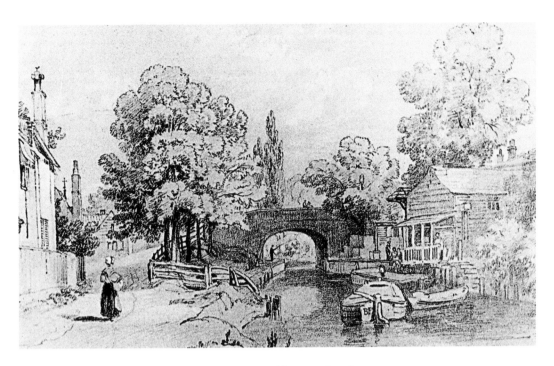

The Croydon Canal, Towards Sydenham Bridge, 1836 and 2014

The Croydon Canal opened in 1809. This sketch by Henry Gastineaux was drawn in 1836, just weeks before the canal closed. The building on the right was Doo's Wharf, run by Henry Doo. He traded as a coal and corn merchant until the canal closed and his wharf was demolished. By 1845, the present Nos 321 and 323 Kirkdale had been built and Henry's son, also Henry, continued the family business from No. 323 Kirkdale until 1860. A railway line from London to West Croydon, via Forest Hill and Sydenham, was built along land acquired from the Croydon Canal Company. This opened in 1839. In the recent view, it is just possible to make out 'Mazawattee' on the wall on the extreme right. This was yet another local tea merchant. The founder, John Boon Densham, lived at the top of Honor Oak Park during the 1860s.

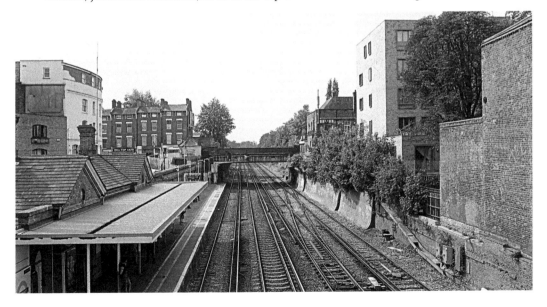

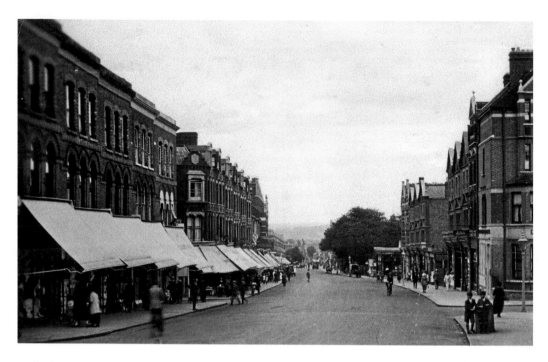

Sydenham Road from the Railway Bridge, Around 1920 and 2014

On the left, Nos 2–6 Silverdale Terrace, now Nos 3–11 Sydenham Road, were built before 1882 and were one of the earliest purpose-built terraces of shops in Sydenham Road. On the opposite side of the road, Darley House, on the corner of Venner Road, was a doctor's surgery from 1887 to 1918. Around 1920, the building was acquired by the London City and Midland Bank, which, in 1923, became the Midland Bank. The bank closed in 2006 and it is now an estate agent.

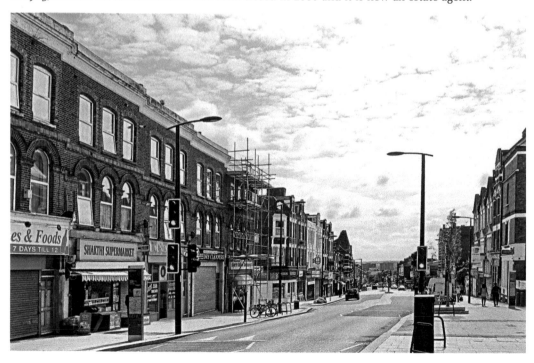

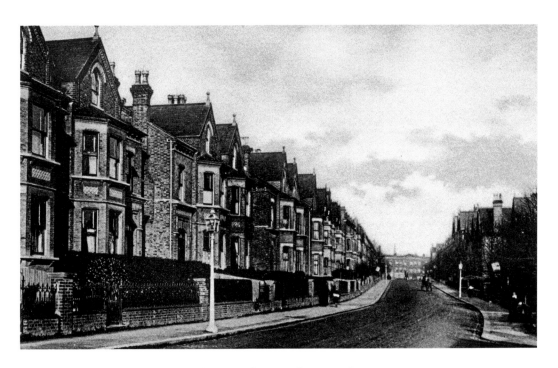

Venner Road Towards Sydenham Road, Around 1910 and 2014

Newlands was a large house on Sydenham Road with extensive grounds that included much of the land between the railway line and Newlands Park down towards Penge. After the last owner died in 1876, his executors sold the house and land for development. By 1878, Venner Road had been laid out and named, possibly after William Fenner, who owned the estate in the late eighteenth century. The first house to be built, out of view behind the photographer, was Crofton Lodge, No. 88 Venner Road. In this view, from the corner of Tredown Road, many of the houses on the left were occupied the early 1880s, but most of those on the right were still under construction.

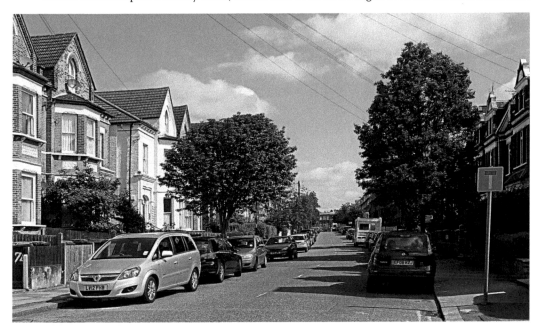

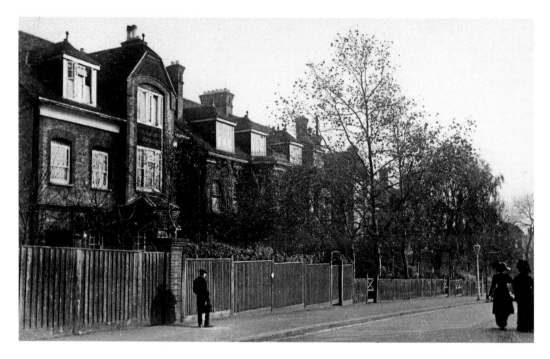

Newlands Park from Sydenham Road, Around 1906 and 2014

Newlands Park began as a field path from Sydenham Road towards Penge, originally called Fenners Lane, and then Penge Lane until 1886. There was a private tollgate at the boundary between Lewisham and Bromley, the rights of which were bought by builders of the new estate around 1878. This view shows Nos 94–104 Newlands Park, part of a development called Priory Villas that continued down to Tannsfeld Road. Building began around 1882. Out of view on the left is Volkspares. A century ago, this site was occupied by livery stables, and by 1933 it was Sydenham Car Service.

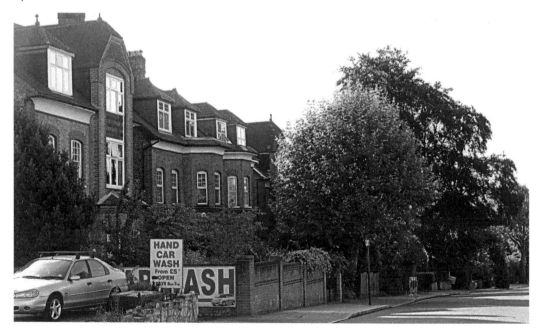

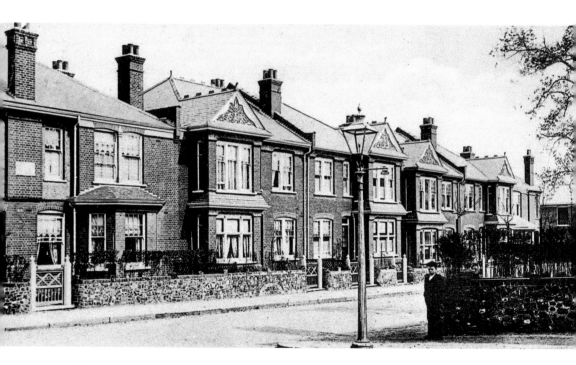

Earlsthorpe Road from Queensthorpe Road, Around 1908 and 2014

The Thorpes were built on part of the Old House estate, which originally extended, approximately, from the railway line on the west to Mayow Road on the east, and from Sydenham Road to Perry Vale. Like all land in Sydenham and Forest Hill, apart from common land, it was private and anyone trespassing could be prosecuted. When the last owner of the estate, Mayow Wynell Adams, died in 1898, his heirs were keen to sell the land. It was auctioned and James Edmondson, a builder who had recently completed a development at Muswell Hill, bought it. He began building the Thorpes in 1901. This picture shows Nos 3–7 Earlsthorpe Road. Ernest Sneath, an architect and surveyor, lived at No. 2 Earlsthorpe Road, behind the hedge on the right, between 1902 and 1905. He shared business premises with Edmondson in Muswell Hill and was clearly the architect of the estate.

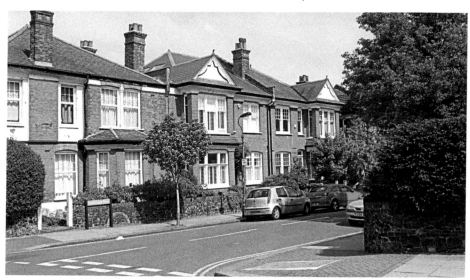

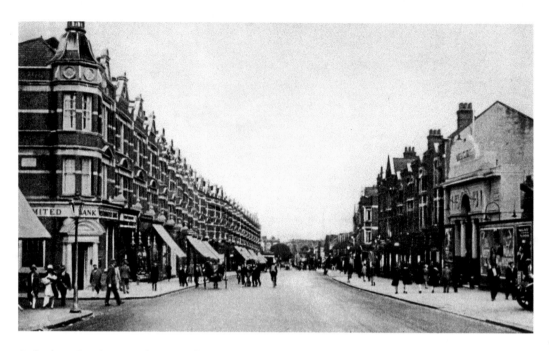

Sydenham Road, Around 1930 and 2014

Queensthorpe Road is on the left. Grand Parade, the terrace of shops between Queensthorpe Road and Mayow Road, was built by Edmondson from 1902. In 1906, Edmondson's opened an estate agent at No. 83 Sydenham Road, from where they rented their newly built houses. On the right is the Queens Hall Electric Theatre, which opened in 1910. After a couple of years as The Classic, it became the Naborhood Cinema in 1939. The cinema suffered from bomb damage in 1943 and was closed, never to reopen. It was demolished in 1953 and the site remained derelict until 1971, when an 'old persons' centre' and a post office were built. A council meeting decided that 'The Naborhood Centre' was an appropriate name for the new building. The name was recently changed to The Sydenham Centre.

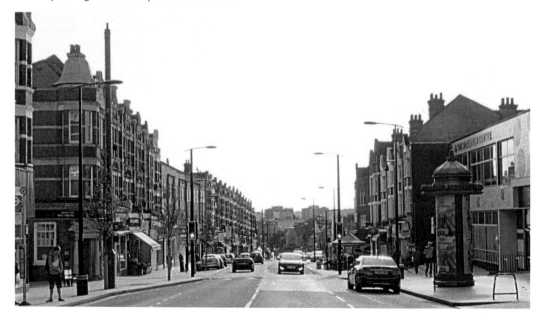

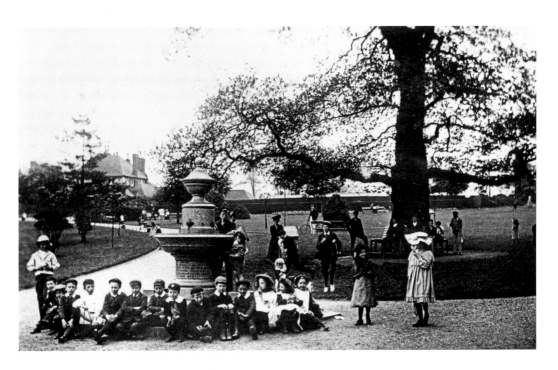

Mayow Park, Around 1910 and 2014

In May 1875, a letter appeared in the *Sydenham, Forest Hill and Penge Gazette* declaring: 'every portion of available land in our neighbourhood is being taken for building purposes, and very speedily will Sydenham and Forest Hill be one network of roads and streets'. The writer, Revd William Taylor Jones, the headmaster of Sydenham College, was seeking donations and urged wealthy inhabitants to 'make a sacrifice for their less fortunate neighbours'. The land for a park was made available by Mayow Wynell Adams of the Old House at around 'half its market value'. The park was laid out by the Lewisham Board of Works, predecessor of the present council, and was formally opened on 1 June 1878. The drinking fountain commemorates the leading role played by the Revd Taylor Jones in establishing Lewisham's first public park. F. J. Horniman was treasurer of the fundraising committee and the most generous donor.

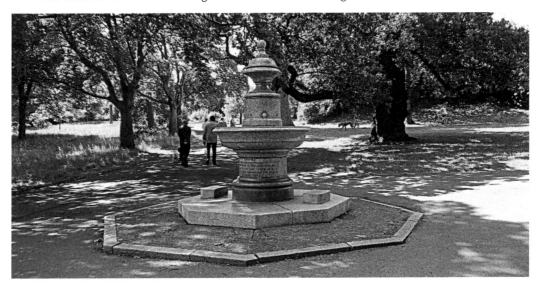

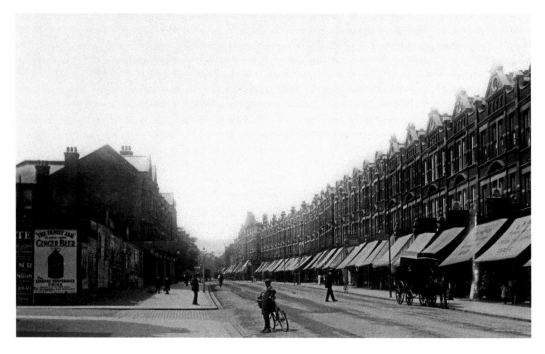

Looking Up Sydenham Road, Around 1914 and 2014

Girton Road is on the left. The site on the corner remained undeveloped until the State Cinema, later the Granada, was opened in 1931. The cinema closed in 1971 and was demolished. The site is now occupied by the Co-operative store. Further up the road, on the other side, Nos 71–85 were seriously damaged on 7 October 1943, when a Junkers Ju88, under heavy shelling, jettisoned its bombs. The shop on the extreme right was Owens' bakery, which began trading here before 1906. They were still here in 1940. Around 1971, Tom Slatter opened his bakery. Although it was rebranded as The Cake Store around 2000, it is still run by the same family.

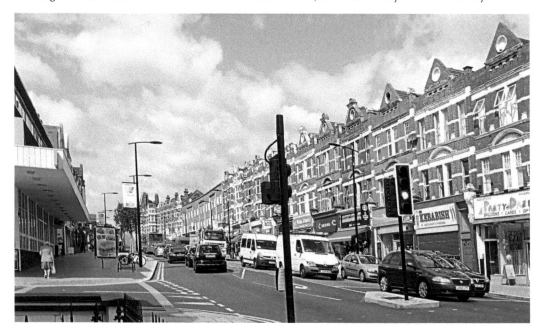

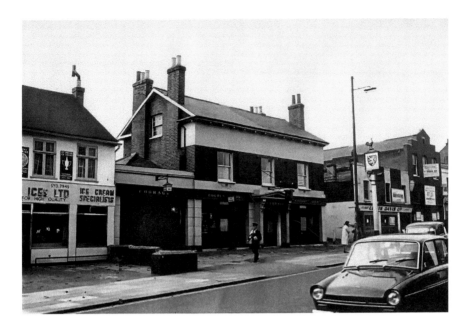

The Golden Lion and Criterion Ices, 1960s and 2014

The Golden Lion began trading in 1732. The pub was rebuilt in the 1850s and in 1855, it was granted a licence for theatrical performances. It was around this time that the hall at the back was built. Although much altered, the hall still survives. There was also sufficient land at the back of the pub for a cricket pitch and quoits and skittle grounds. James Valenti, the founder of Criterion Ices, had a fishmonger's at No. 132 Sydenham Road, on the site of the Hexagon building, from around 1927. During the mid-1930s, he began making ice cream at No. 125 Sydenham Road, behind the funeral directors' next to the Dolphin. This building was previously used by Lings, who made their Turkish Delight there before moving to Kemble Road. James Valenti sold ice cream from his old fishmonger's shop until more suitable premises, next to the Golden Lion, became available in 1939. This provided the space both to make and sell their ice cream. Although Criterion Ices still produces excellent ice cream, their original shop in Sydenham closed around 2000.

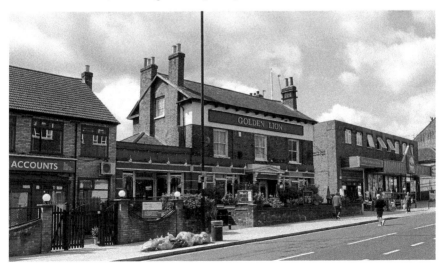

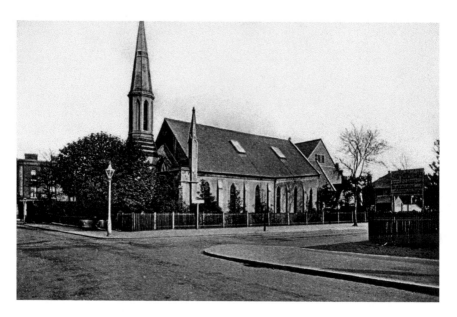

Episcopal Chapel, Corner of Trewsbury Road, Around 1910 and 2014

This is one of the oldest buildings in Sydenham. In 1670, a house on the site of the chapel was used as a Dissenters meeting hall and the chapel was built there before 1760. In 1794, it became an Anglican place of worship, Christ Church. In 1845, the building was 'thoroughly repaired ... when a small spire in the early English style was added'. It had another period as a Non-Conformist chapel from 1867 until 1879, when it became a chapel of ease for St Michael's, Champion Park. In 1903, the chapel became All Saints church hall and it is likely that the spire was removed around this time. The building was finally converted into flats in 2000.

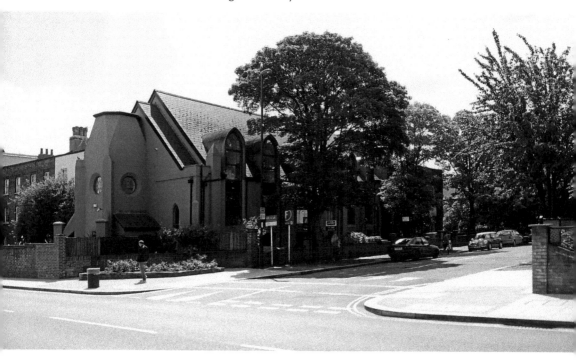

Nos 197–201 Sydenham Road, 1970s and 2014

Originally called Nos 1 and 2 Wilson Place, the redbrick houses at Nos 197–199 were probably built in the 1780s, while No. 201, which still survives, dates from the 1830s. No. 199 was claimed to be Sydenham's smallest house. These two cottages were demolished around 1992, when the Peartree Care Home was built. Around 1860, a beer shop called The Prince Alfred opened at No. 201. Five years later, it moved across the street to a new building on the corner of Kent House Road.

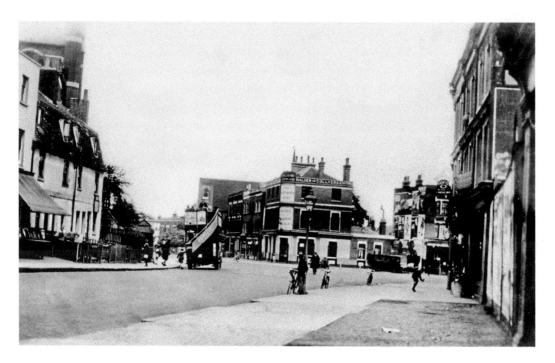

The Prince Alfred, Sydenham Road, 1920s and 2014

On the extreme left is the building in which the pub originally opened. When the present pub was built on the corner of Kent House Road, it included a terrace of shops known as Alfred Terrace, built to generate extra income for the brewery. Beyond that, on the other side of Watlington Grove, is the prominent roof of the earlier church of Our Lady and St Philip Neri. The terrace of shops on the near right, curving round into Kent House Road, was built in 1868 and was originally known as Kent Terrace. Around 1978, H. Sivyer opened their waste removal service behind No. 160 Sydenham Road. The site had been used by a haulage contractor from around 1905.

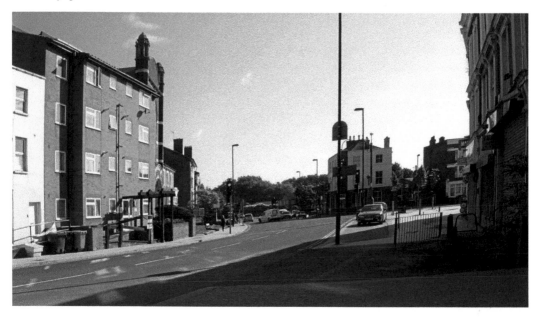

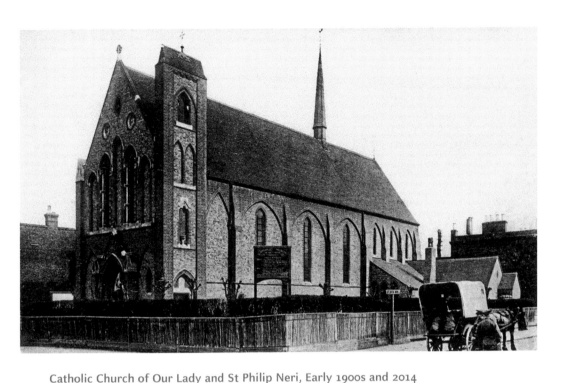

Catholic Church of Our Lady and St Philip Neri, Early 1900s and 2014

The Catholic church originally opened in a temporary tin church on the corner of Addington Grove in 1872. In 1878, a plot of land was bought on the corner of Watlington Grove and the new church eventually opened in 1882. On 13 September 1940, the church received a direct hit and was seriously damaged. It was closed and boarded up. It was not until 1959 that the present church was built, between the presbytery and the library. As the War Damage Commission could not give sufficient funds to replace the church as it was, the congregation had to settle for 'a plain substitute building', designed by Stanley Kerr-Bate and opened on 5 June 1959. The square tower was added in 1961.

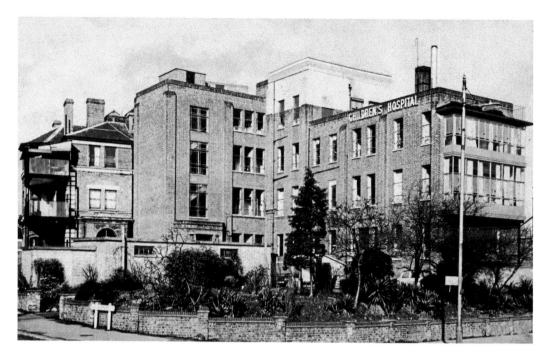

Sydenham Children's Hospital, Around 1970 and 2014

In 1861, a property developer, William Woodgate, bought The Lawn estate in Lower Sydenham. His intention was to build a church as the centrepiece of a prestigious group of houses, to be called Champion Park. The first building, Champion Hall, was built in 1862 for Alexander Rowland. Rowland's company made Macassar Oil, used by Victorian gentlemen to condition their hair. However, Rowland's invention stained the backs of chairs and led directly to the introduction of antimacassars. In 1885, the Sydenham Children's Hospital, which had opened at Nos 5 and 6 Albion Villas Road in 1872, moved to Champion Hall. It was much enlarged, to adapt it for changing needs, but the original Champion Hall remained at the core and can be seen on the left of this picture. In 1991, the hospital closed and was subsequently demolished. Many still have fond memories of the Children's Hospital, either as patients or parents.

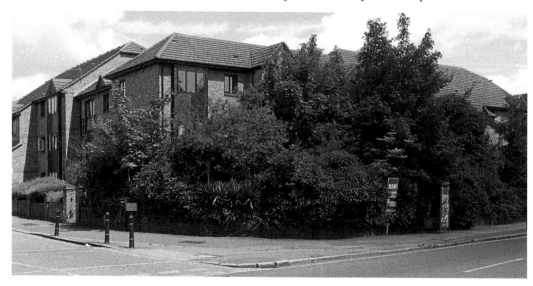

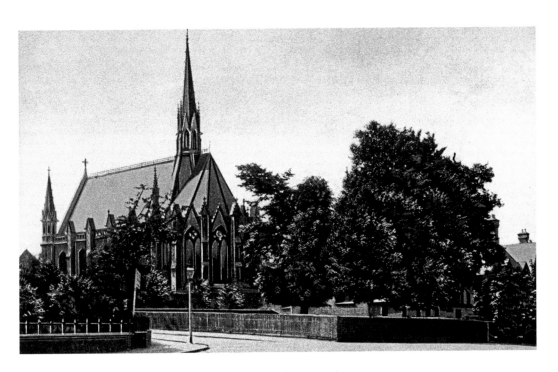

St Michael's Church, Champion Park, Around 1910 and 2014

The proposed Champion Park was never built. The gasworks was expanding and those who could afford it were moving uphill towards the Crystal Palace. St Michael and All Angels, a striking church built in 1864 to the designs of James Knowles, and St Michael's school were the only other buildings of this grand development to be completed. St Michael's was destroyed in an air raid on 10 September 1940 and the present building was erected in 1958 to the designs of David Nye. However, the original school survives. It was designed in 1871 by Edwin Nash, a local architect who was also responsible for the apse, roof and interior of St Bartholomew's, St Philip's church, Taylors Lane (demolished 1992) and St Philip's Church School, Coombe Road (demolished 2012).

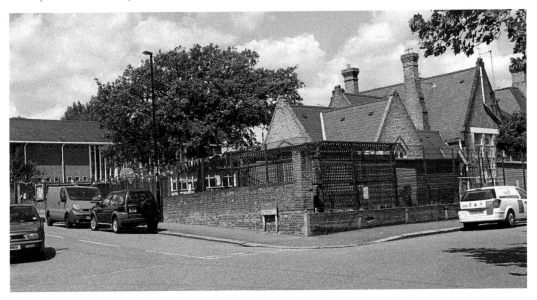

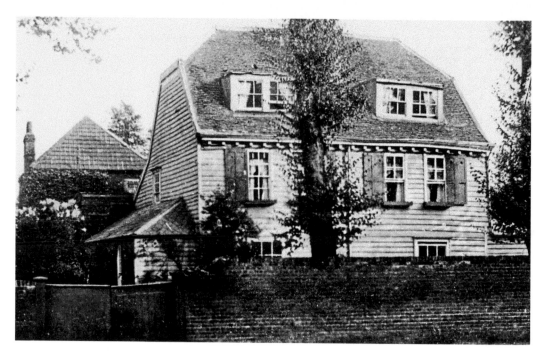

Sir George Grove's Cottage, Sydenham Road, Around 1912 and 2008

This house was built in the late seventeenth century as a pair of cottages. Sir George Grove lived here from 1860 until his death in 1900, and Lady Grove continued here until her death in 1914. In 1919, Grove House became the presbytery of Our Lady and St Philip Neri. In 1930/31, because of the poor condition of Grove House, particularly the leaky roof, it was demolished and replaced with the present presbytery. The small extension, set back on the left, was added while Sir George was living there and is the only surviving part of his house.

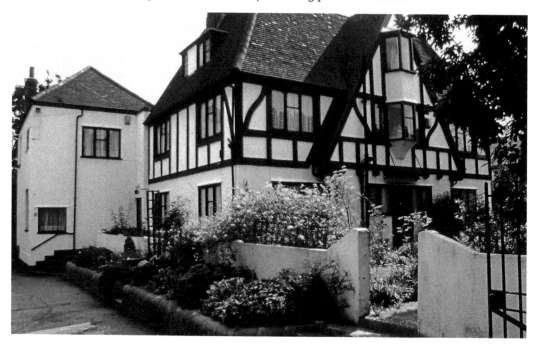

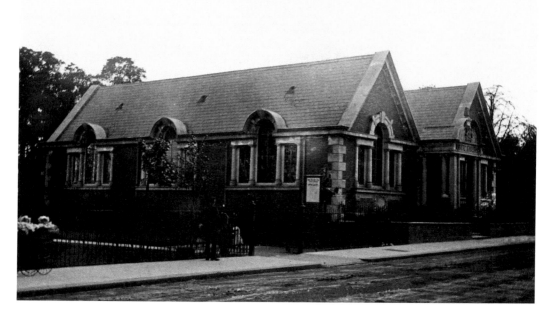

Sydenham Library, Around 1906 and 2014

When Lower Sydenham Public Library (its official name) opened on 24 September 1904, it was one of the first Carnegie Libraries built in England. Andrew Carnegie, a Scotsman who went to America and became one of the world's richest men, believed those who acquire great wealth had a duty to redistribute it and also that access to information was an essential part of helping people improve their situation. He therefore put much of his wealth into founding libraries in areas where they would be of most benefit. The Trustees of Sir George Grove were prepared to sell part of his estate for the new library. During the 1960s, following concerns about the safety of the entrance from Sydenham Road, the council decided to build a new entrance on the Home Park side of the library.

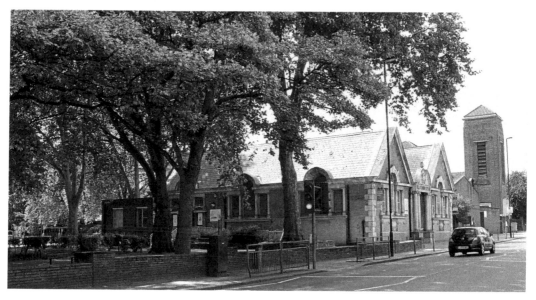

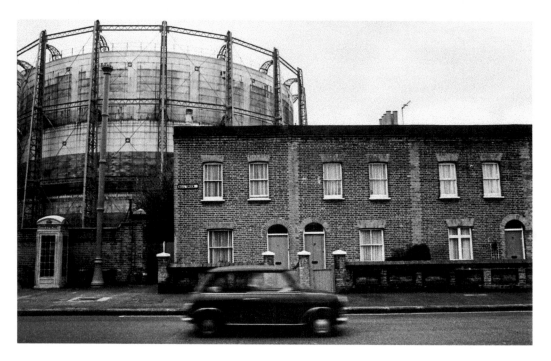

Gas Works, Bell Green, Around 1965 and 2014

The Sydenham Gas and Coke Company opened at Bell Green around 1853, as a direct response to the imminent arrival of the Crystal Palace. Although beneficial in many ways, it had a defining influence on Lower Sydenham. Terraces of small cottages were built for the gas workers and their families, while more prestigious developments, such as Champion Park and Fairlawn Park, faltered. This picture shows Nos 1–5 Bell Green, built specifically for gas workers. Behind them is one of the surviving gasholders. John and Alice Quinn lived at No. 13 Bell Green from 1911 until John's death in 1932. They lost four sons during the First World War, although only two are mentioned on the memorial at the Livesey Hall.

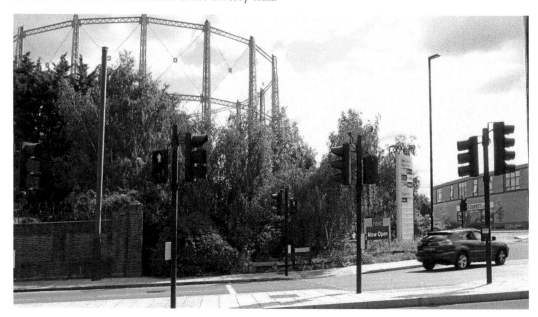

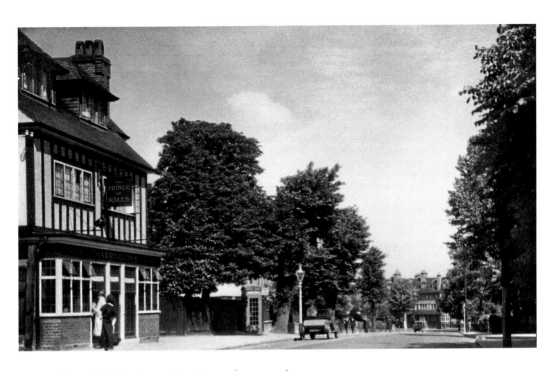

Prince of Wales, Perry Rise, Around 1924 and 2014

By 1843, Thomas Shaw, who had previously been the landlord of the Fox and Hounds in Kirkdale, had built six cottages along a small lane off Perry Rise. Although the cottages have since been rebuilt, the lane is still called Shaw's Cottages. The Prince of Wales, which was licensed around 1847, opened in the first cottage, facing Perry Rise. It was enlarged until, in 1926, it was entirely rebuilt. Unfortunately, the leaded ground floor windows were replaced fairly recently. In the distance is the Forest Hill Fire Station.

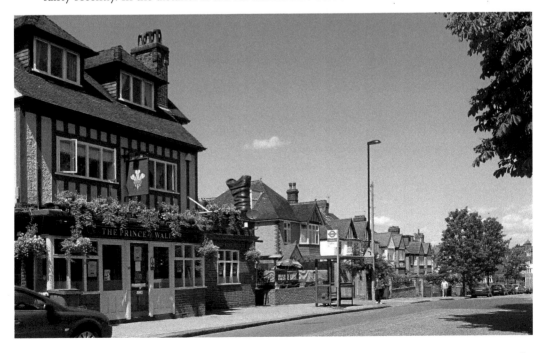

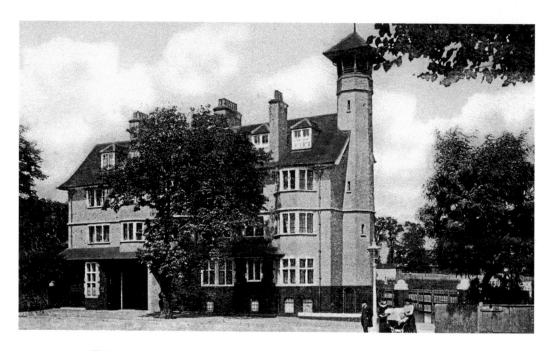

Forest Hill Fire Station, Perry Vale, Around 1904 and 2014

Forest Hill's first fire station was in London Road, opposite Sainsbury's. It was demolished around 1900 when Dorrell Bros. acquired the land and built Nos 45–47 London Road. The fire station moved temporarily to Perry Vale, in the yard by Forest Hill Station. In 1902, this impressive new fire station was opened by the London County Council. It was designed in Arts and Crafts style, probably by Charles Canning Winmill, the LCC Fire Brigade Department's principal architect. It was originally intended for horse-drawn fire engines. Above the station were flats for twelve firemen and their families. In 1972, an even more modern fire station was built in Stanstead Road and the Perry Vale station closed. It was listed Grade II by English Heritage in 1973.

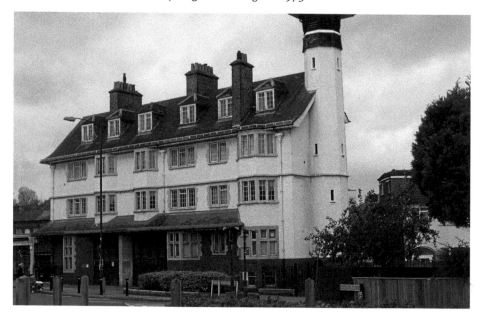

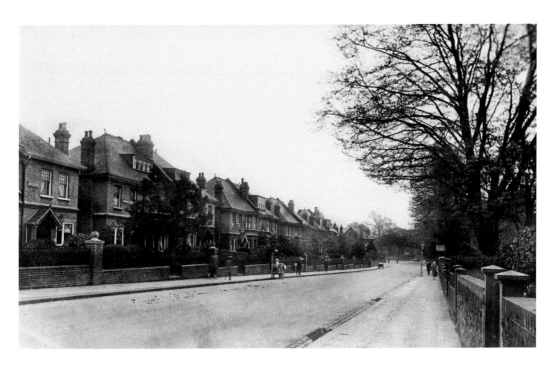

'Christmas Houses' in Perry Vale, Around 1924 and 2014

These distinctive houses, together with the large houses opposite and houses in Sunderland Road, Gaynesford Road and Church Rise, were built by Ted Christmas from around 1901. The Perry Vale houses were named so that the initial letters spelt 'Ted Christmas' and those opposite spelt 'Laura', his wife. Those in Sunderland Road spelt 'Grace', his daughter. There are other Christmas houses in the area, notably in Thorpewood Avenue and Round Hill.

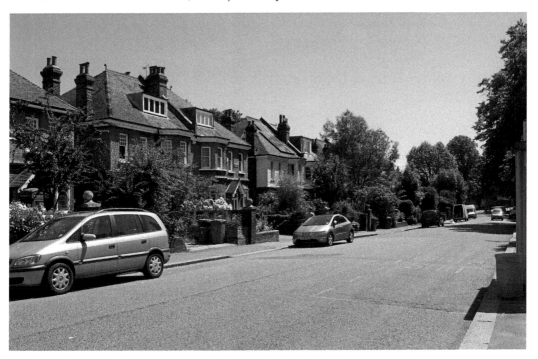

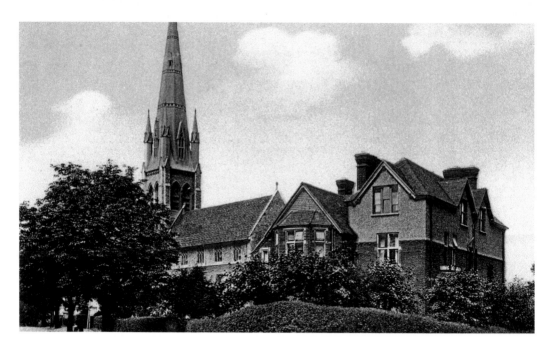

Christ Church, Forest Hill, Around 1910 and 2014

Built in 1854, Christ Church was the central feature of Dartmouth Park, a prestigious estate bounded by Waldram Park Road, Westbourne Road, South Road and Sunderland Road. The estate was built on what had for centuries been Lammas land, private land owned by the Earl of Dartmouth that, from harvest until the following spring, could be used as common land. That right was lost with the passing of the Lewisham Enclosure Act in 1812. The principal developer of Dartmouth Park was William Colson, born in Forest Hill in 1815 and founder of the brewery in Perry Vale. When Christ Church was converted into flats in 2005, the graveyard was cleared of most of the gravestones. Fortunately, several were kept including the monument to the Tetley family, founders of Tetley Tea, and George Baxter, colour printer.

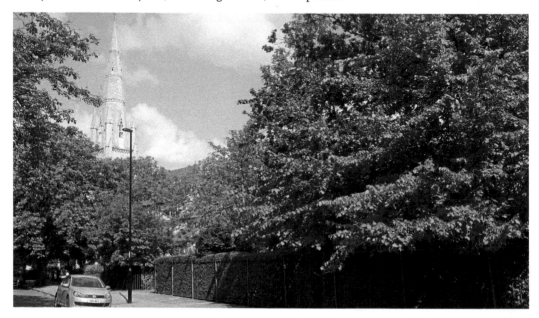

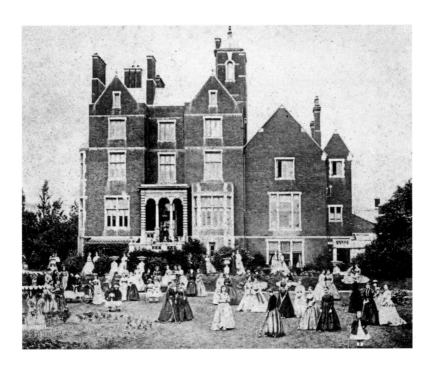

Tudor Hall, South Road, Around 1880 and 2014

Red Hall was built opposite Christ Church, South Road, around 1855, when the occupant was Matilda Murray. It has been suggested that she was 'possibly' the Hon. Amelia Matilda Murray, maid of honour to Queen Victoria. In fact, she was almost certainly Matilda Murray, the widow of Robert Murray, a surgeon. Her sister, Emily Giovanna Robertson, also widowed, was living at Red Hall between 1858 and 1863. In 1864, Revd John Wood and Matilda Todd moved their girls' school from Perry Hill to Red Hall, calling it Tudor Hall Girls' School. This view shows the school from the back garden. The picture was taken before the spire of Christ Church was built in 1885, otherwise it would have been visible to the left of the hall. Tudor Hall was demolished in the early 1960s. Only the extension to the right and the lodge, on South Road, survive. Although Tudor Hall School moved from Forest Hill in 1908, it is still thriving in Banbury, Oxfordshire.

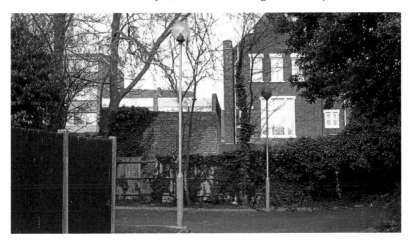

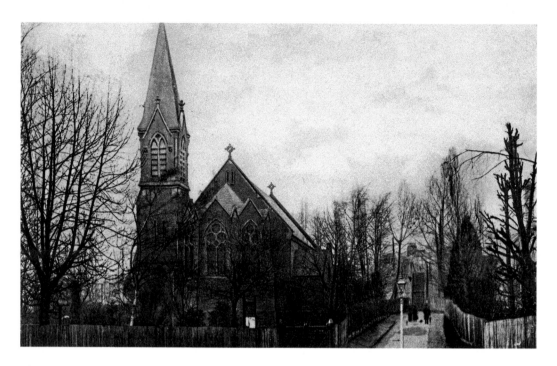

The German Church, Dacres Road

After the opening of the Crystal Palace in 1854, a substantial German community began to develop in the area consisting mainly of merchants, traders and bankers. They decided to form their own church and the German Episcopal church held its first service at Park Hall, Sydenham Park in 1874. By 1883, they had raised sufficient funds to build a church in Dacres Road. Dietrich Bonhoeffer was the pastor of the church from 1933 to 1935, when he lived at No. 2 Manor Mount, above a school run by two German sisters. In 1935, he returned to Germany and joined the anti-Nazi movement, and was apparently involved in the plot to assassinate Hitler. He was arrested in 1943 and hanged in April 1945. The church suffered severe damage during the war and was rebuilt in 1959 to the designs of G. S. Agar. It was dedicated to Dietrich Bonhoeffer.

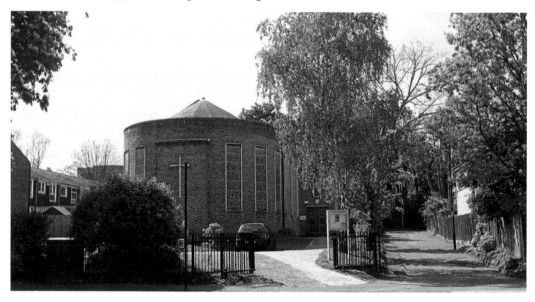

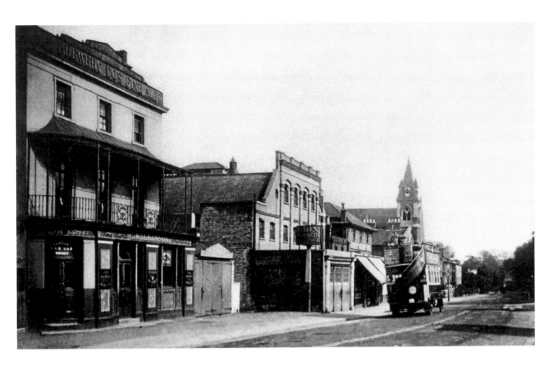

The Foresters Arms, Perry Vale, Around 1922 and 2014

The Foresters, now the All Inn One, probably opened around 1847 on the opposite corner of Hindsley's Place in a building later to be called The Armoury, the headquarters of the 8th Kent Rifle Volunteer Corps. This building was demolished a few years ago. As the Forest Hill branch of the Ancient Order of Foresters, a friendly society, was founded in 1845 and probably held their earliest meetings here, it is likely that the pub's name is derived from them. The present pub was built in the early 1850s and the Foresters continued to meet there until 1865, when their own hall in Clyde Vale opened. Until quite recently, the pub sign displayed the coat of arms of the Foresters. At around the same time as the pub opened, a brewery also opened between the pub and Church Vale. In 1926, the brewery was sold and became part of United Dairies. On the other side of Clyde Vale was the Trinity Methodist church, built in 1866 and closed in 1930.

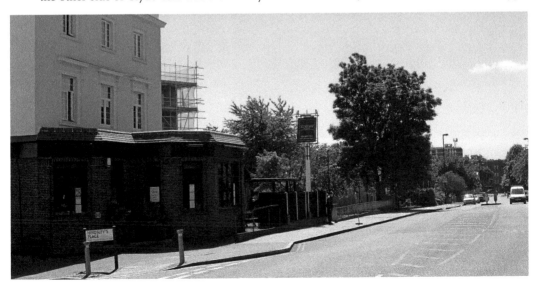

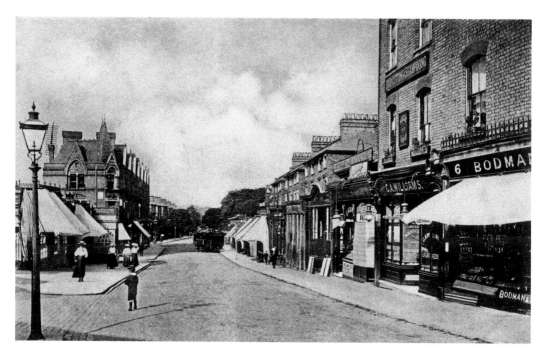

Perry Vale, Towards Waldram Park Road, Around 1904 and 2014

On the right, the building with the arched fascia, just past C. A. Williams, was The Oxford Arms, No. 23 Perry Vale. It opened as a coffee house around 1861, but by 1869, it was an alehouse. It closed in 1907. This whole terrace, from Nos 9–27 Perry Vale, was originally semi-detached villas built in the late 1840s. By the 1860s, they were already being converted to shops. The large terrace of shops on the left was designed by James William Brooker, a local architect, in 1875. It was originally called 'The Pavement' and this can still just be seen over the gabled window on the corner, above Distinguish Doors. As Brooker's father was a builder, he presumably built The Pavement. James Brooker also designed the Primitive Methodist Chapel in Stanstead Road.

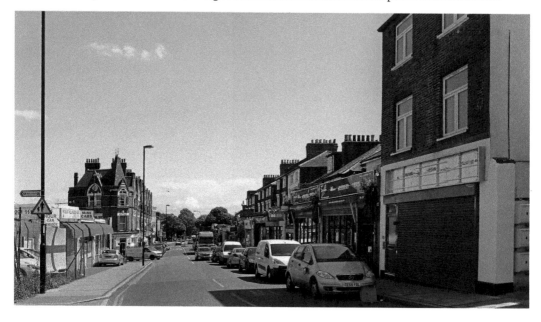

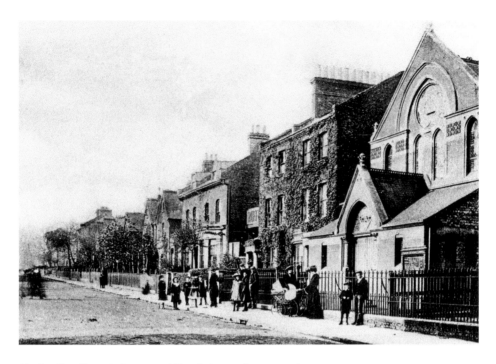

Methodist Chapel, Stanstead Road, Around 1904 and 2014

The Primitive Methodist Chapel was founded in a small cottage in Bird in Hand Passage, off Dartmouth Road, in 1856. Ten years later, they moved to Stanstead Road, and in 1881 ,this much larger church was built, designed by James Brooker. The front of the original building was redesigned in 1913. To the left of the chapel is Clifton School, a 'ladies preparatory school', from 1882 until 1929. This group of houses was demolished when the Unicorn Darts factory was built in 1954. Fifty years later, the factory was demolished when the present building was erected.

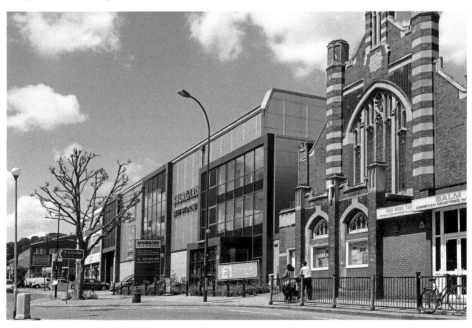

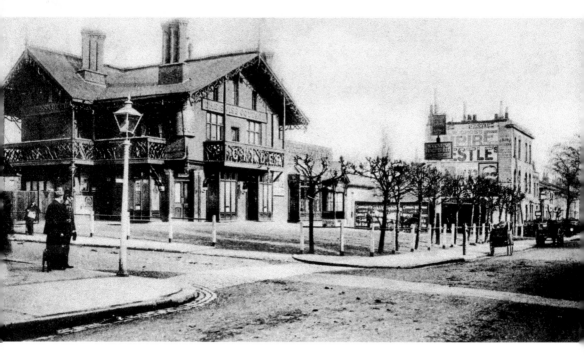

Swiss Cottage, Stanstead Road, Around 1910 and 2014

The pub was first licensed in 1854. Harry Harley Ginder and his wife managed it from 1905 to 1935. During the 1980s, the pub was rebranded as Tyrol's. As often happens when a pub's name is changed, it closed a few years later. After a developer was refused permission to demolish it, the building mysteriously burnt down. The present block of flats was built in 1992.

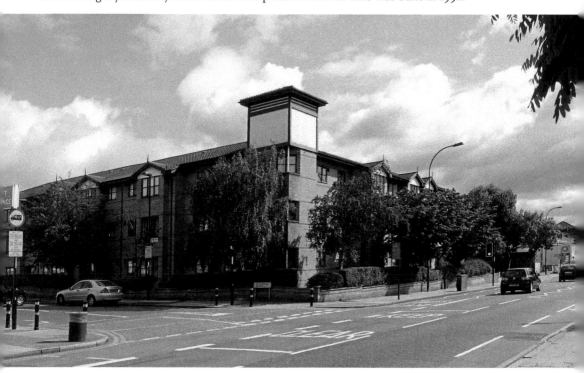

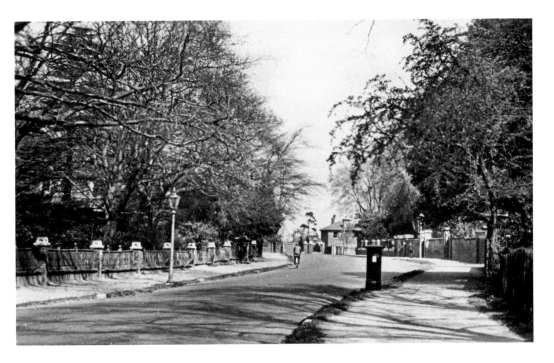

Sydenham Hill Towards Kirkdale, 1950s and 2014

Holly Brow is in the distance and, barely discernible through the trees on the left, is Lapsewood. It was built around 1861, probably by Charles Barry, the Dulwich College architect, who lived there until 1871. Barry had previously lived at No. 40 Sydenham Park from around 1852, some six years before he succeeded his father as architect to the Dulwich College Estate. This raises the possibility that he was involved with the development of Sydenham Park. By 1894, he was living at Stanley House, No. 112 London Road, and now part of Horniman Gardens.

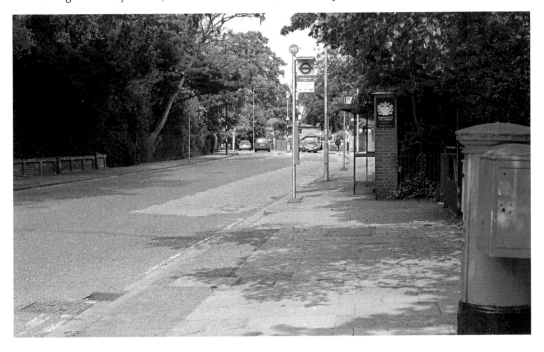

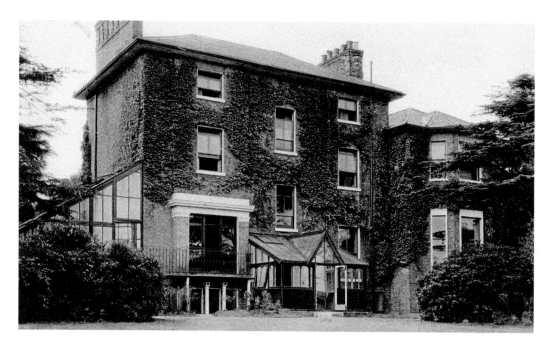

Manor House, No. 38 Sydenham Hill, Around 1908 and 2014

This shows the house from the back garden. It was built around 1855 and the first occupant was George Joseph Cockerell, a coal merchant. It was on the site of these garages, on the south-west corner of Lammas Green. On the enclosure of the common the Bridge House Estates, set up to raise funds for the maintenance of London Bridge, was awarded the large plot that includes Lammas Green, Mais House (Lord Mais was Lord Mayor of London 1972/73) and Sedley Court. They promptly put four boundary posts at each corner of the plot, bearing their symbol with the date '1816' and at least three still survive, in front of Sedley Court, at the end of the footpath from Lammas Green to Kirkdale and in front of these garages, on the right. Lammas Green, designed by Donald McMorran, was built by the Corporation of the City of London around 1955 and is listed Grade II by English Heritage.

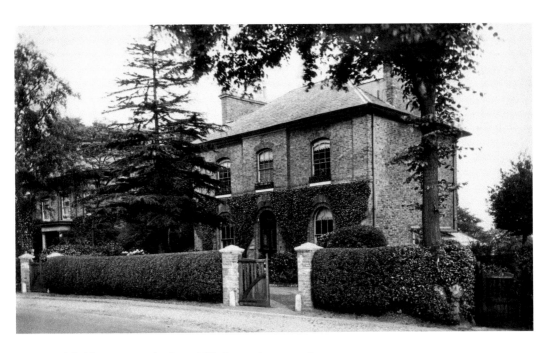

Highfield, No. 28 Sydenham Hill, Around 1912 and 2002
The house still survives as part of the Abbeyfield Care Home. It was built around 1858, probably for John Coe who was one of the main campaigners for the Kirkdale Institute. He was also in charge of printing bank notes for the Bank of England. In 1864 he moved to White Lodge, London Road (*see p. 30*). Highfield was divided into flats in 1958 and around 1989 it became a home for the elderly.

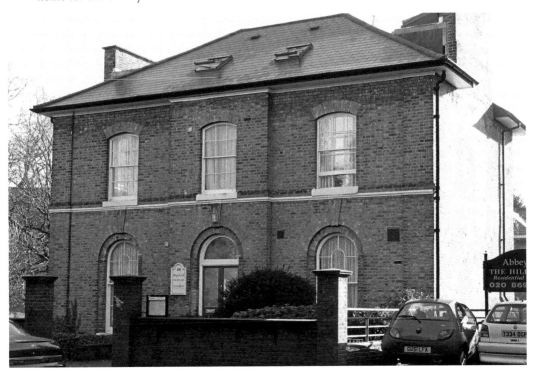

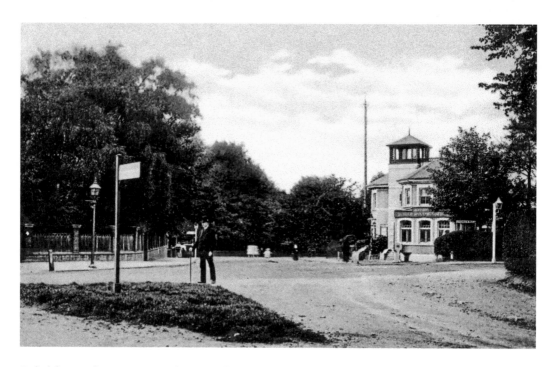

Dulwich Wood House, Around 1910 and 2014

The Dulwich Wood House was built in 1857 to the designs of Banks and Barry. It was built specifically to catch the passing trade on its way to the Crystal Palace. The first publican was George Ward. He had been a bricklayer and may well have been involved in building the Wood House. He left the Wood House in the mid-1860s and lived in Coombe Road, off Wells Park Road, where he was described as a contractor. A more famous landlord was Rex Palmer, who was at the Wood House in the early 1950s. In December 1922, he was one of the first five employees appointed by the BBC. He was a radio presenter and performed on children's programmes as Uncle Rex. He also sang 'Abide with Me' at the end of each evening's broadcast.

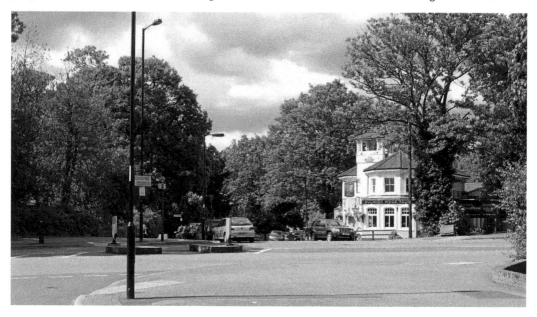

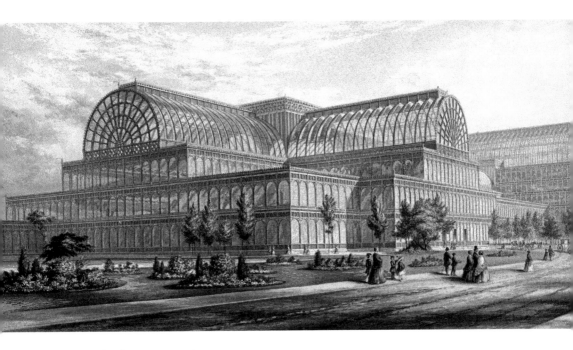

The Crystal Palace, 1854 and 2014

The enclosure of Sydenham Common in 1819, the construction of the railway line to Croydon in 1839 and the opening of the Crystal Palace on Sydenham Hill in 1854 were the principal events in the development of Sydenham and Forest Hill. It cannot be coincidence that when the Crystal Palace Company was formed in 1852, three of the eight original directors, John Scott Russell, Thomas Newman Farquhar, and Samuel Laing, had strong Sydenham links. This print by George Baxter shows the Crystal Palace shortly after it opened in 1854. Baxter was the first to develop and market colour prints. He lived at The Retreat, Peak Hill from 1860 until his death in 1867.

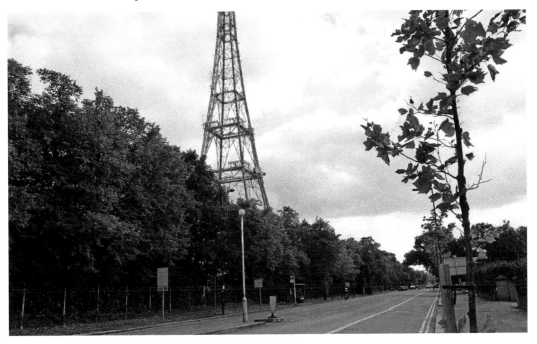

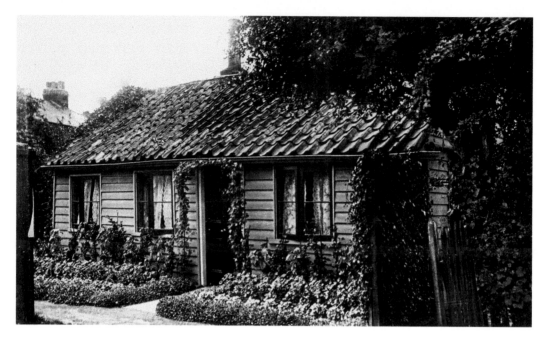

Wells Cottage, on the Corner of Oaksford Avenue, Around 1910 and 2003

Around 1640, water seeping from springs on Sydenham Hill, in the area of Wells Park, was found to have medicinal properties and people started to visit Sydenham to take the waters. To ensure a regular supply, some twelve wells were formed and the Sydenham Wells became quite a popular attraction. John Evelyn and Daniel Defoe both visited but the high point came with a visit from George III. Wells Cottage had been in the same family from perhaps 1726. Alexander Roberts married Susannah Herbert at St Mary's, Lewisham in that year and his great-great-great-grandson, James Coling, was living in the cottage when it was hit by a VI bomb in 1944. James moved to Taylors Lane where he died in 1958, 230 years after his family first arrived in Sydenham. James Coling claimed that he still had the table and chair at which George III sat.

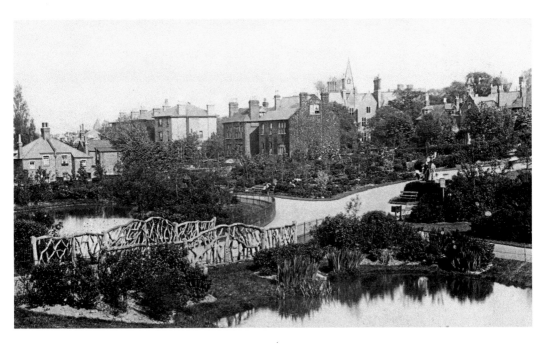

Wells Park, Around 1906 and 2014

Whereas Mayow Park and Home Park were 'recreation grounds', designed primarily for sporting activities with level playing fields, Wells Park was intended for relaxation with its ornamental flowerbeds, ponds and pleasing views. The park was opened in 1901 and this picture must have been taken soon after. It was in the Wells Park area that springs emerging from the hillside formed streams that flowed down towards the Pool River at Bell Green. One spring still emerges, flowing into the pond on the right of the picture, under the path to the duck pond and then into a culvert where it continues underground to the Pool River at Bell Green. Of the houses that dominate the earlier view, a few still survive, including Nos 16–20 Taylors Lane and Nos 16, 18, 7 and 9 Longton Grove.

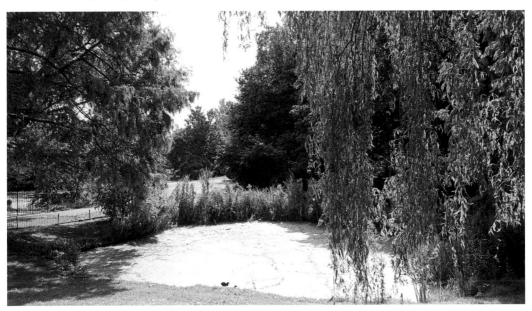

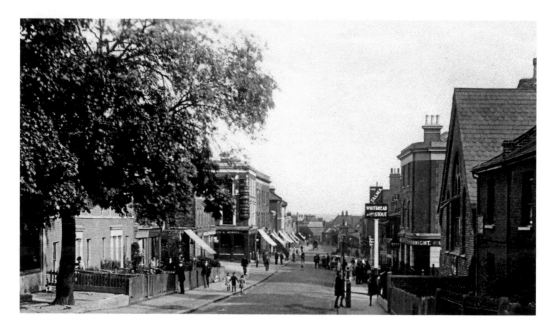

View Down Wells Park Road, Around 1930 and 2014

Wells Park Road was originally called Wells Lane or Wells Road as it led up the hill to Sydenham Wells. It became Wells Park Road in 1937. The Talma began trading in 1863, but it is probable that the present building dates from the 1880s. There was a large hall at the back of the building and between 1866 and 1871, it was licensed for theatrical performances. It is assumed that the pub was named after the French actor Francois Joseph Talma (1762–1826), who is shown on the pub sign. However he died some forty years before the pub opened. Another possible explanation is that 'Talma', in Hebrew, means 'hill'. The Duke of Edinburgh, later The Duke, was first licensed in 1866. It survived, fairly intact, until demolished in 2007. Also demolished, in 2012, was St Philip's Church School, on the near corner of Coombe Road. This, like the original church, was designed by Edwin Nash.

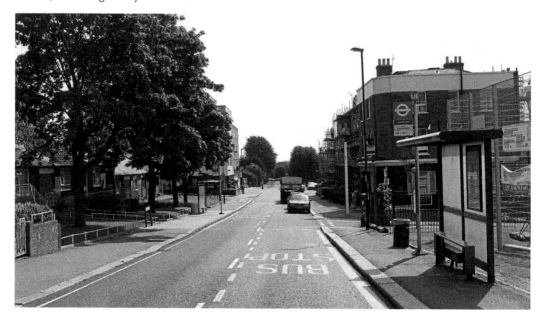

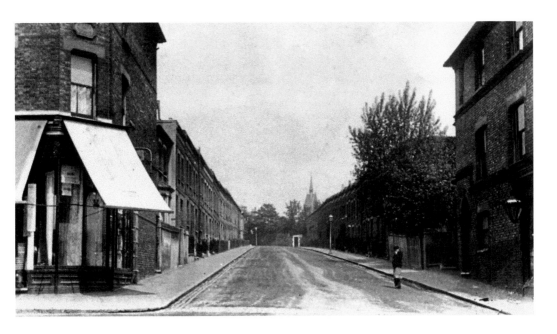

Dallas Road, Around 1910 and 2014

The small terraced houses were built around 1873 and were, in most cases, occupied by two families. Most of the men were tradesmen or labourers whereas the women were either laundresses or dressmakers. In the distance is the spire of St Matthew, Panmure Road, demolished in 1939. From 1957, the Wells Park Road area was targeted for redevelopment. The *Manchester Guardian* picked up on the threat and stated that there were 'three streets of real value – Halifax Street, Wells Park Road and Mill Lane'. It added, 'They are small and suit modern life, are economical in plan and well built'. Some of the houses had been described as 'slums'. The *Guardian* commented on the way similar houses had been restored in Chelsea and Islington and wondered whether the term 'slum' was used as an excuse for avoiding the responsibility of caring for the houses. Only Halifax Street managed to survive, mainly because the houses were a bit larger and the residents more influential.

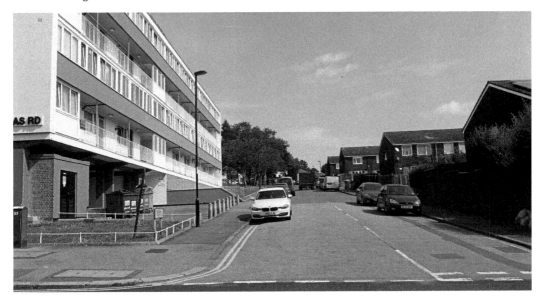

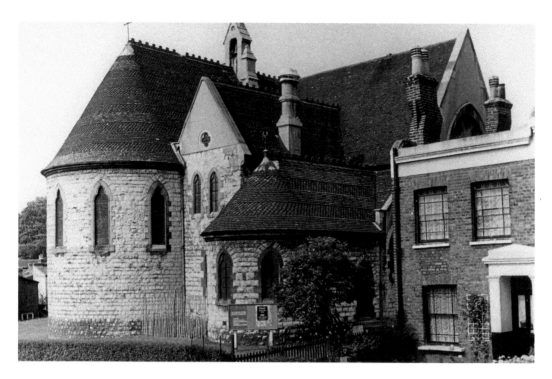

St Phillip's Church, Coombe Road

The church was designed by local architect Edwin Nash in 1867 and consecrated as a chapel of ease for St Bartholomew's church. Revd George Hilaro Philip Barlow was appointed curate. In 1869, St Philip's became a parish church in its own right and Revd Barlow became the first vicar. The church was demolished in 1982 and the present building opened in 1983. The most prominent survival of the old church is the bell that hangs outside the present church. It was dedicated to Kenneth Barclay, who was killed in action on 12 November 1914. His family lived in Silverdale, he attended Dulwich College and was a choirboy at St Philip's for many years.

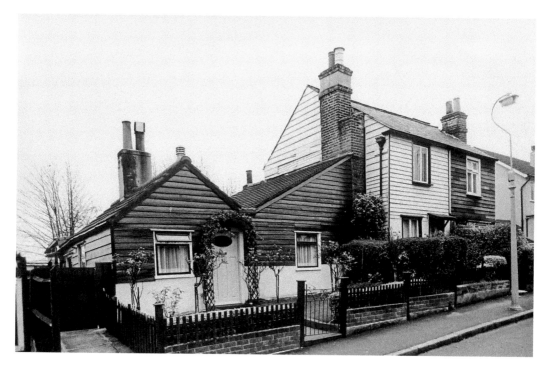

Nos 67–71 Taylors Lane, Around 1972 and 2014

These cottages, originally Nos 1–3 Taylors Lane, were built in the 1820s and are the oldest buildings in Taylors Lane. The Cheasman family, who were agricultural labourers and laundresses, lived at the cottage on the right from the late 1820s until around 1870. It was not until the mid-1860s that other cottages were built in Taylors Lane. The single-storey cottage was demolished a few years ago and replaced by the present No. 71 Taylors Lane.

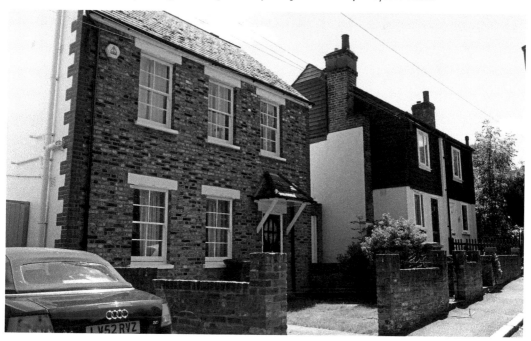

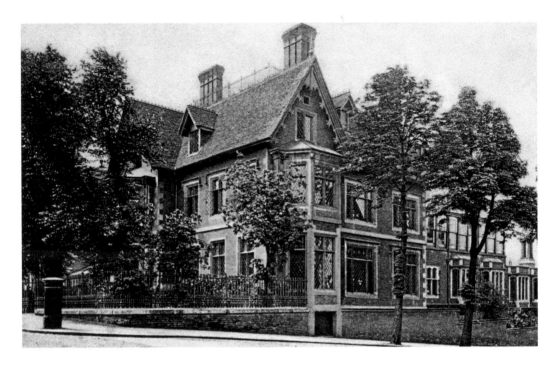

Longton Hall Hotel, Longton Grove, Around 1906 and 2014

In 1854, the year that the Crystal Palace opened, the Longton Hall Hotel also opened on the corner of Westwood Hill and Longton Grove. Its main purpose was to provide accommodation for visitors to the Palace and, according to a letter he wrote, William Holman Hunt stayed there in 1856. Between 1867 and 1872, Longton Hall was the private residence of Richard Preston Beall. At this time, Taylors Lane continued to Westwood Hill and Beall decided to close it off to protect his privacy. There was local outrage and many hundreds of people gathered to destroy the fences. They succeeded and this stretch of Taylors Lane remained open until the mid-1970s. On 22 February 1887, Sydenham High School opened in this building. Extensions were added and a neighbouring house acquired, but by the 1920s it was becoming clear that the building and grounds were inadequate and they needed to move.

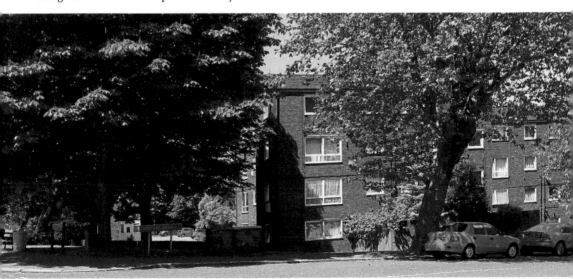

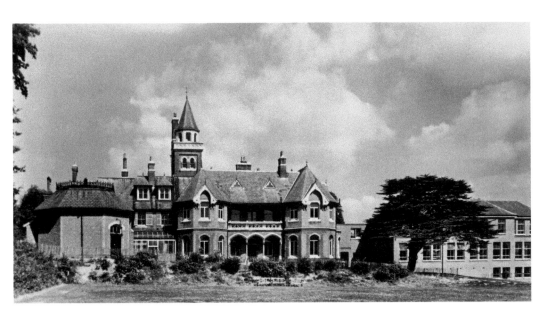

Sydenham High School, Around 1936 and 2014

Horner Grange was built for William Knight in 1884. He made a vast fortune out of diamond and gold mines in South Africa. He lived at Horner Grange until his death in 1900. From around 1924 until 1933, the house became the Horner Grange Residential Hotel. When the hotel closed, Sydenham High took the opportunity to buy the freehold. On 26 April 1934, pupils and staff gathered in the old school for a final assembly. After morning prayers they 'filed over and took possession of their new home'. Almost immediately, new buildings were erected and tennis courts laid out in the back garden. Horner Grange survives, with many of its original features, at the heart of the present school.

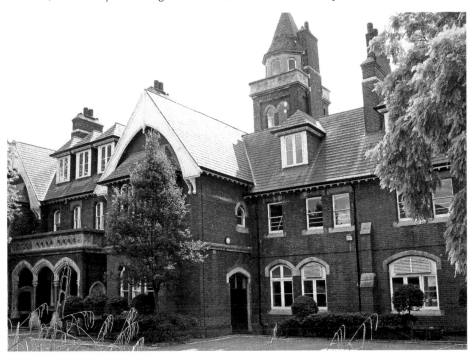

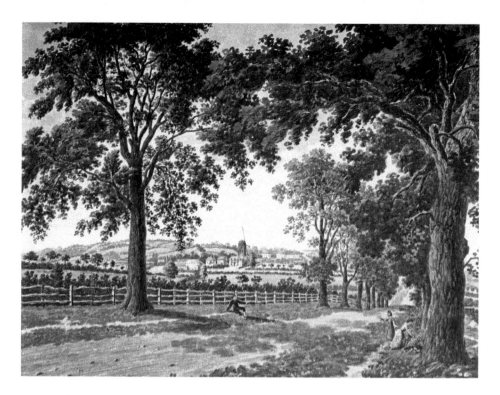

Jews Walk, 1836 and 2014

Frederick Fairholt painted this view in 1836. He was standing near the Westwood Hill junction looking towards Kirkdale. In the centre, between the trees, is Wells Park Road with Sydenham Mill, built in the early 1830s, prominent in Mill Close. Jews Walk was originally lined with elm trees, but they gradually died during the 1850s. This was blamed variously on vandalism by navvies building the Crystal Palace or, more plausibly, the installation of mains drainage damaging the roots. The significant dip in Jews Walk was for centuries the bed of a small stream that flowed from the springs in Wells Park. Much of its route down the hillside towards the Pool River near Bell Green can still be traced through the Wells Park allotments and across Jews Walk and Kirkdale. The stream continued across Peak Hill (now Spring Hill) where a visitor to Thomas Campbell's house referred to crossing 'a small rill'. It then flowed across Silverdale and Mayow Road and on to Bell Green.

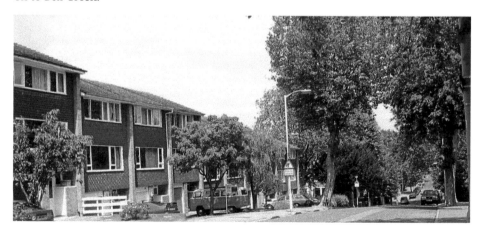

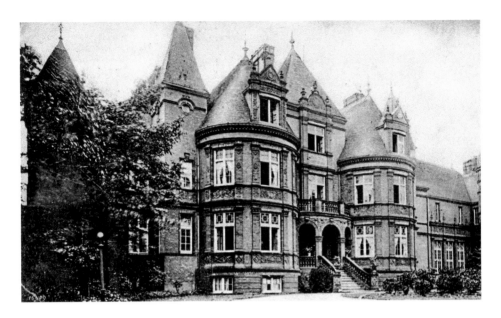

Westwood House, Around 1908 and 2014

Westwood House was built on the edge of Sydenham Common around 1767. Its first owner, David Ximenes, a Sephardic Jewish merchant, obtained permission to plant an avenue of trees across the common from what is now Kirkdale towards his house. The avenue soon became known as 'The Jew's Walk' and is one of the oldest street names in Sydenham. In 1874, Henry Littleton, proprietor of Novello & Co., the world's largest music publisher, bought Westwood House. In 1879, he employed John Loughborough Pearson to enlarge and embellish it. This included adding a grand music room, visited by Franz Liszt and Antonin Dvorak. In 1899, the house became the Passmore Edwards Orphanage for the Children of Teachers. The orphanage was evacuated during the war and never returned. Around 1950, Lewisham Council bought the house and it was demolished and the Shenewood estate was built. There is some confusion over the spelling. Sheenewood and Sheenwood are on signs round the estate. In fact, it should be Shenewood, after the Prior of Shene, who was the Lord of the Manor of Lewisham in the fifteenth century.

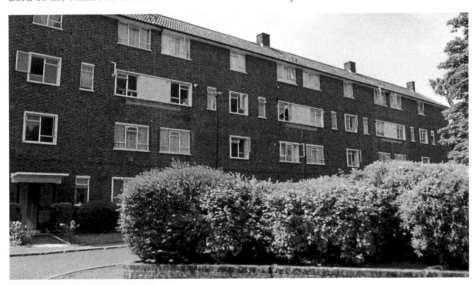

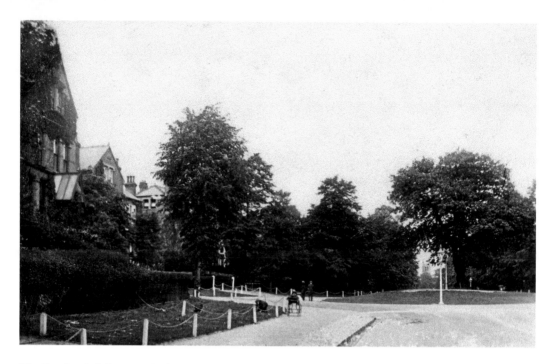

The Border Oak from Sydenham Avenue, 1905 and 2014

This view shows St Bartholomew's church in the distance. The border oak marks the boundary between the ancient parishes of St Mary Lewisham and St George, Beckenham and also the present boroughs of Lewisham and Bromley. During the war, the houses on the left suffered severe bomb damage and were demolished when the Chulsa Estate was built in 1953. Between 1910 and 1918, Fernwood, the farthest of the three houses, was occupied by Alexander Duff Henderson. He was owner of the family shipping business, The Aberdeen White Star Line. His only son, Patrick, died on 11 May 1918 of wounds received in action and is remembered on the St Bartholomew's war memorial.

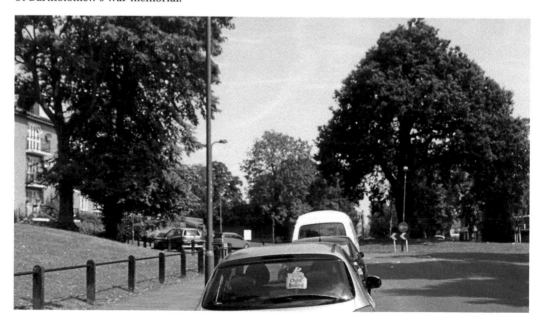

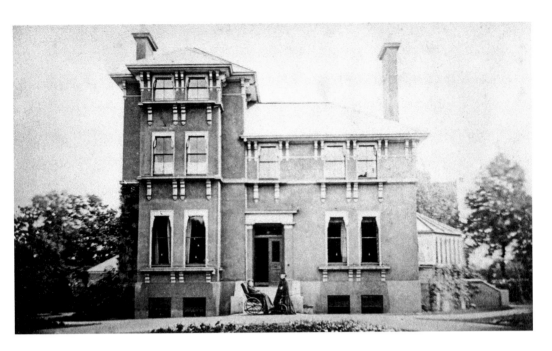

Oak Lea, Lawrie Park Avenue, 1868 and 2014

Oak Lea, by the Border Oak, was built around 1861 when Harriet Price and her sister-in-law Charlotte moved in. This photograph shows Harriet and Charlotte in the front garden. Both died at Oak Lea, Harriet in 1880, and were buried in St Bartholomew's churchyard. The original conservatory at the side of the house was replaced by the present extension in 1893 and by the mid-1930s, Oak Lea had been divided into flats.

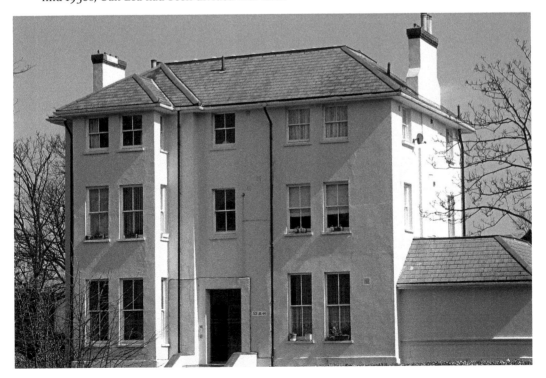

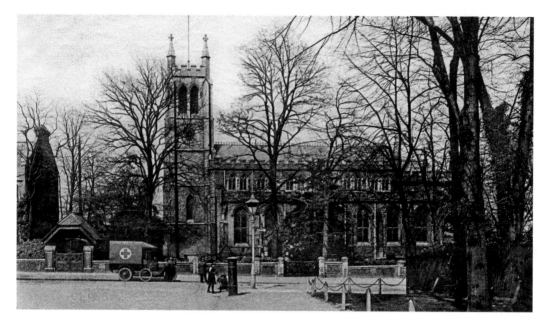

St Bartholomew's from Lawrie Park Avenue, Around 1914 and 2014

Until 1855, Lewisham (only the southern part of the present borough, Deptford was entirely separate until 1965) was a single parish with one parish church, St Mary's, near the present Lewisham Hospital. In 1824, to make it easier for people in Sydenham to attend church more regularly, it was decided to build a chapel of ease. Eventually, after struggling to raise sufficient funds, finding a suitable site and then agreeing on the plans, the chapel was consecrated on 30 August 1832. On 8 February 1855, St Bartholomew's and Christ Church, Forest Hill became parish churches, the first created within the ancient parish of Lewisham. In 1858, the chancel, designed by Edwin Nash as a memorial to Revd Thomas Bowdler, was added. Further repair and restoration work was carried out in 1873/74 when 'all except the outer walls had been completely rebuilt after the beautiful designs of Mr Nash'. The roof over the nave and aisles was also rebuilt. In 1922, one of the finials on the tower broke off and it was decided, for safety's sake, to remove the remaining three.

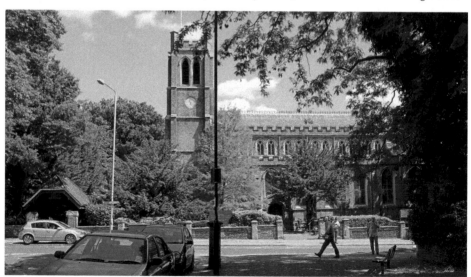

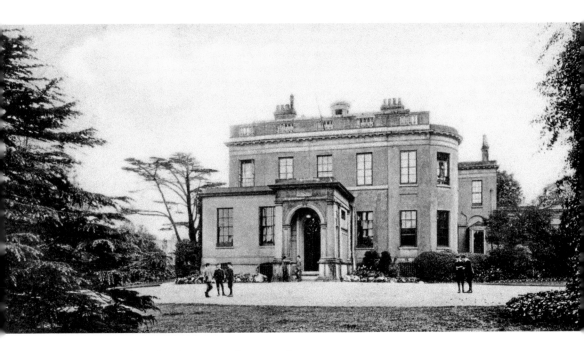

Sydenham Hall, Hall Drive, Around 1910 and 2014

Hall Drive, known simply as The Drive until 1937, originally led to Sydenham Hall, on the site of Nos 15–19 Hall Drive. The building was originally a farmhouse on the edge of Sydenham Common but was rebuilt in the early nineteenth century. Around 1806, the house and grounds were bought by Andrew Lawrie. The Lawrie family lived there until 1852 when the estate was bought by the Crystal Palace Company. Around 1902, Sydenham Hall became a school and when the school closed in 1938 it was demolished.

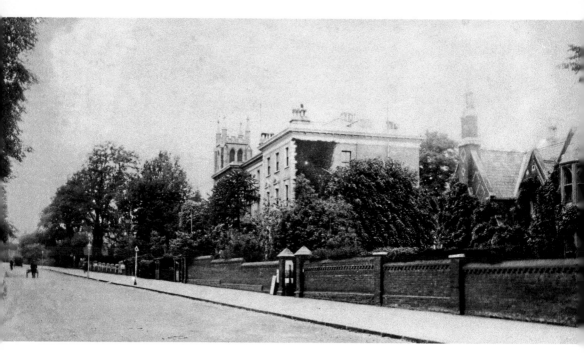

Westwood Hill Towards St Bartholomew's, Early 1920s and 2014

On the right is the original St Bartholomew's parsonage, an elaborate neo-Gothic building erected in the late 1840s. On 2 July 1944, the building was destroyed by a bomb. A section of the garden wall, by the bus stop, survives. Between the parsonage and the church was a terrace of three villas built in the 1850s. In 1919, the villa next to the vicarage became the new Church House, where the Verger lived and meetings were held. Prior to this, the Church House had been in Wells Park Road, which was considered rather inconvenient.

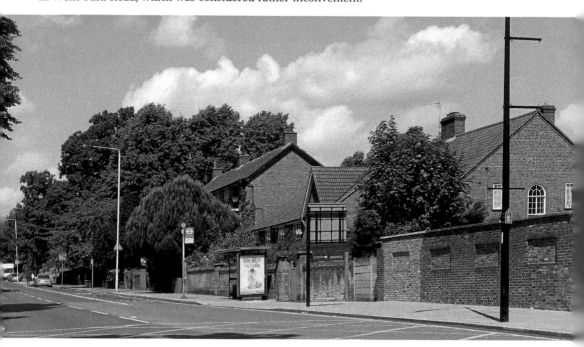

Beckenham Through Time

David R. Johnson

This fascinating selection of photographs traces some of the many
ways in which Beckenham has changed and developed over the
last century.

978 1 4456 1976 7
96 pages, full colour

JOHN D. BEASLEY

EAST DULWICH

THROUGH TIME

East Dulwich Through Time

John D. Beasley

This fascinating selection of photographs traces some of the many
ways in which East Dulwich has changed and developed over the
last century.

978 1 84868 550 5

96 pages, full colour